PAUL KLEE AT THE GUGGENHEIM

Essay by Andrew Kagan
Introduction by Lisa Dennison

GuggenheimMUSEUM

All works by Paul Klee © 2003 Artists Rights Society (ARS), N.Y./
VG Bild-Kunst

ISBN 0-89207-106-0 (hardcover)
ISBN 0-89207-107-9 (softcover)

Guggenheim Museum Publications
1071 Fifth Avenue
New York, New York 10128

Printed by El Viso, Madrid

Cover: Detail of *Red Balloon (Roter Ballon)*, 1922
Oil (and oil transfer drawing?) on chalk-primed gauze, mounted on board
31.7 x 31.1 cm
Solomon R. Guggenheim Museum 48.1172x524

Paul Klee at the Guggenheim Museum
Guggenheim Museum SoHo
May 21–August 23, 1993

This exhibition has been organized by the Solomon R. Guggenheim
Museum and has been made possible through the generous support of
Swiss Bank Corporation.

SPONSOR'S STATEMENT

Founded in 1872, Swiss Bank Corporation has a strong tradition of supporting the arts. Seeing the world and experiencing it in new ways through art reinforces the energy and importance of individual insight and the creative process, two critical values fundamental to the operating philosophy of our Bank. Thus, we take great pleasure in sponsoring *Paul Klee at the Guggenheim Museum*, on view at the Guggenheim Museum SoHo. Paul Klee, who was born and died in Switzerland, is a leading figure of Modernism and one of this century's most beloved artists. As a draftsman, painter, and teacher, his influence has been enormous. Klee is among our finest cultural treasures, and we are certain that this rare exhibition of the acknowledged masterpieces and lesser-known, but beautiful, works that comprise the Guggenheim's Klee collection will bring enjoyment to all who experience it. We are grateful for this very special opportunity to share his legacy with the public.

Walter G. Frehner
Chairman of the Board of Directors

 Swiss Bank Corporation

PREFACE

The Guggenheim Museum's seventy-seven paintings and works on paper by Paul Klee are among the institution's greatest riches. The Guggenheim collection spans virtually the entire career of this important artist—from the landscapes and satirical etchings that Klee produced while he was a teenager, to masterpieces made at the Bauhaus, to whimsical abstract compositions created in the last years of his life. These works have been seen only rarely. Limited exhibition space has been perhaps the most significant restriction; the fragility of much of the work has been another. As a result, this is the first full presentation of Klee's work from the collection in sixteen years.

In many ways, *Paul Klee at the Guggenheim Museum* is a modest exhibition. It is, nevertheless, a complex undertaking that was made possible only as a result of three important developments: the additional exhibition opportunities presented by this museum's recent expansion; creative solutions by Paul Schwartzbaum, Assistant Director for Technical Services and Chief Conservator, and his staff to the problems of extreme fragility inherent in the artist's use of unusual and fugitive materials; and the strong and consistent commitment of Swiss Bank Corporation to assisting the Guggenheim in making its permanent collection accessible to a wider audience.

Many of these works are so fragile that the conservation department was compelled to design special frames for individual items, each of which contains its own perfectly balanced climate. The installation of these masterpieces in the beautiful Arata Isozaki–designed galleries testifies to the profound tangible benefits of this museum's expansion to SoHo. The extraordinary support of Swiss Bank Corporation, in these economically challenging times, dramatically underlines the importance of corporate involvement to the cultural life of this city.

Most important, the exhibition of this Swiss-born Modern master reveals an intensely complex oeuvre that has captivated successive generations of artists. Paul Klee is an artist of deeply personal imagery that speaks with an extraordinary universal authority. At the end of the twentieth century, with its absence of powerful normative direction, Klee reaffirms the strength of individual creativity and reminds us again of the infinite potential of visual imagery.

Thomas Krens
Director, The Solomon R. Guggenheim Foundation

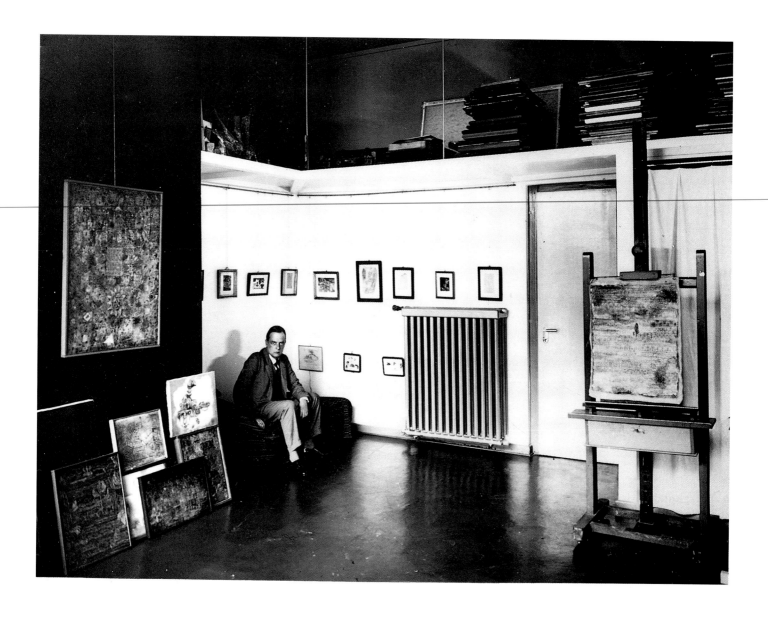

I N T R O D U C T I O N

Lisa Dennison

Few artists of the twentieth century have as great a reputation as Paul Klee. His legacy as a painter and draftsman is prodigious, comprising over 9,000 works in all mediums, which he assiduously catalogued and classified in an elaborate inventory system. His legacy as a writer is equally copious and forms an introspective analysis that parallels his art in its complexity and inventiveness.[1]

What sets Klee apart from others of his rank is that his success is not tied to the singular, identifiable masterpiece. To be sure, there are works within his oeuvre that are unqualifiably of masterpiece quality, but they were not created with this as an ultimate goal. Klee's whole approach to making art was fundamentally different, oriented not toward definitive statements but rather toward a lifelong process of reexamining and redefining themes and forms within a body of work. Klee refused to follow a developmental path that was either linear or evolutionary. As Harold Rosenberg has written: "His formal inventiveness was so profuse as to make creation appear a natural function of the mind. . . . Most artists who discover a mode keep digging in it until it forms a crater that encompasses them—for example, Chagall, Mondrian, Rothko. In contrast, Klee cut analytical trenches from one mode to another to construct a seemingly endless labyrinth."[2]

Klee did not believe that a point of completion was possible in a world based on flux, change, and motion. He maneuvered freely between abstraction and representation throughout his career, whereas other artists of his generation, such as Vasily Kandinsky, pursued a more rigorous course toward the non-objective. Unlike Klee's, Kandinsky's stylistic development can be broken down into discrete phases characterized by different modes of formal invention and pictorial organization. Kandinsky also created works within series, such as the *Improvisations*, *Compositions*, and *Impressions*.[3] Although Klee made many works on themes, including music and the theater, he usually created them over a larger span of time and in a nonsequential arrangement. Another difference between the two artists lies in the use of studies. Kandinsky built his masterpieces on extensive preliminary studies in which one can trace the evolution of compositional devices and motifs. In creating the Guggenheim Museum's *Painting with White*

Border (1913), for example, he made at least fifteen drawings, watercolors, and oil sketches.[4] Klee, on the contrary, did not make studies. Throughout his lifetime he continually recapitulated many of the same themes, formal elements, and techniques in independent works in all mediums.

Klee's choice of materials and scale in certain respects conspired against the masterpiece concept. He did not subscribe to the traditional hierarchy of mediums; oil painting was by no means privileged in his oeuvre. He often used etching, engraving, watercolor, gouache, tempera, and oil in various combinations, and experimented with them further by applying them to canvas, burlap, linen, gauze, board, and other less-conventional supports. The scale of his works was decidedly not monumental, although Klee was always challenged by the possibility of projecting a larger space than the physical size of a work allowed. As Rosenberg recognized, the notebook size of Klee's paintings can imply a certain tentativeness:

> A painting appears to be in a state of being superseded by one based on a different conception or by a different version of itself. In their totality, Klee's works suggest the jottings of a seeker, not the "major statement" of one who has arrived at finality. . . . Sheer magnitude can bestow upon a work the character of a final act. The temptation to bring art to an end . . . is, as we have seen, lacking in Klee. His work assumes the continuation of art and of reflection about it.[5]

Klee deliberately embodied polar opposites in his oeuvre. His style played between the organic and the geometric, the linear and the chromatic, the analytic and the spontaneous; his imagery encompassed representation and abstraction, the personal and the universal, the terrestrial and the cosmic, all within a profoundly harmonic whole.[6] What is most significant is that Klee saw the single work as part of a continuum. As such, his genius is most fully revealed in a group of works in which the fundamental plurality of his vision is evident.

It is not by accident, then, that Klee's work has been collected, by both institutions and prescient collectors, in concentrations. The collection-in-depth forms a lexicon of Klee's artistic expression, within which one can read the signs and symbols of his pictorial vocabulary, the diversity and multidimensionality of his subjects and styles.

The retrospective exhibition provides the ideal circumstances in which to experience Klee's richness. One such opportunity was provided by the Guggenheim Museum's 1967 *Paul Klee, 1879–1940: A Retrospective Exhibition*. One hundred ninety-two works in all mediums graced the spiral ramps of Frank Lloyd Wright's building. In 1987 the Museum of Modern Art, New York, mounted another Klee retrospective, with 233 works. Yet, despite the cooperation of a similar group of lenders, the two shows overlapped in only forty-one examples. Taking into account the twenty-year difference in

time and the subjectivity of the curators who assembled the two shows, this statistic underscores the fact that there is no definitive selection of Klee's work.[7]

Just as there is no definitive retrospective, there is no definitive Klee collection. The Guggenheim's collection is complete only in the sense that it represents all the mediums the artist employed and spans his entire creative life, from the earliest academic landscape sketches made in 1895, when he was a student in Bern, Switzerland (cat. nos. 1–3), to *Boy with Toys* (cat. no. 77), painted in 1940, the year of his death. It includes his early satirical etchings from 1903–05 (cat. nos. 4–8); several gems from his Bauhaus period, including the much-loved *Red Balloon* (1922, cat. no. 27) and *In the Current Six Thresholds* (cat. no. 50), a canvas completed in 1929 after his trip to Egypt; paintings on the theme of music (for example, *New Harmony*, 1936, cat. no. 66); and a group of works bearing the strong hieroglyphic markings of his last phase (for example, *Peach Harvest*, 1937, cat. no. 69). Even so, there are gaps in terms of chronological sequence and depth.[8]

By far the richest holdings of Klee's work are located at the Kunstmuseum Bern. In addition to its own collection, the museum houses the Paul Klee Stiftung, which preserves art and essential documents belonging to the artist's estate. The foundation's holdings include forty paintings, 2,253 drawings (almost half the artist's entire production in this medium), 163 colored drawings, eleven sculptures, twenty-eight glass paintings, eighty-nine prints, and ten sketchbooks. As a center for research on Klee, the Kunstmuseum Bern is unparalleled. Yet it is not the only European museum with a rich repository of Klee's production. The Kunstmuseum Basel holds over a hundred works in all mediums, which have entered the collection since 1930. The Städtische Galerie im Lenbachhaus, Munich, has fifty-two works in its collection, partly through the donation of Gabriele Münter, Kandinsky's longtime companion.

The formation of several of the most important Klee collections involved an interchange between American and European institutions and collectors. Among early Klee collectors in the United States was Duncan Phillips (founder of the museum in Washington, D.C., that bears his name), who purchased nine works by the artist in the late 1930s and early 1940s. G. David Thompson in Pittsburgh also assembled a collection during this period; it now forms the nucleus of the Kunstsammlung Nordrhein-Westfalen in Düsseldorf, Germany. Comprised of ninety-two works, it is one of the largest public collections of Klee's work in the world. Prior to leaving his native Germany in 1936, the collector and dealer Heinz Berggruen had never seen a work by Klee.[9] He purchased his first example by the artist during a trip to the United States and went on to assemble an extraordinary Klee collection. Although Berggruen amassed the bulk of his holdings while he was a dealer in Paris, he donated all ninety of his Klees to the Metropolitan Museum of Art, New York, in 1984. Among the works by Klee

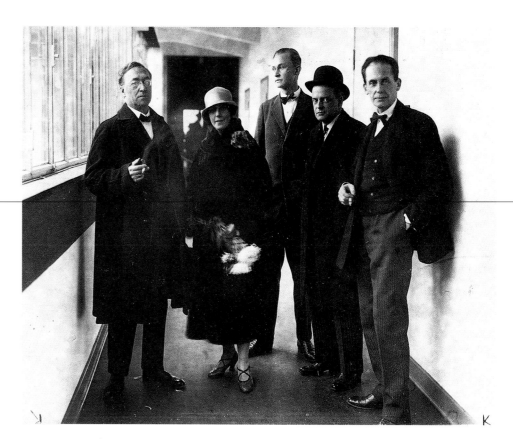

that eventually came to the United States from German museums are a significant
number that had been banned by the Nazis as "degenerate art."[10]

The Guggenheim's Klee collection was formed in the context of fascinating circum-
stances. To understand the collection's origins more fully, it is valuable to explore both
how Klee's work was first brought to the attention of the American public,[11] and how
the artist himself, who never set foot on American soil, came in contact with the
founders of the Guggenheim Museum and with the other visionary patrons whose per-
sonal collections subsequently enriched the museum's holdings.

Because of the dominance of Cubism and the School of Paris in the United States in
the 1920s, American collectors and critics were slow to recognize the advanced art of
Germany. It was, finally, Swiss-born Klee and Russian-born Kandinsky who led the
vanguard of early twentieth-century German art in the United States, through the col-
lective efforts of a few important pioneers. One of the most ardent and enlightened
champions of German art was Katherine S. Dreier, who in 1920 with Marcel Duchamp
founded the Société Anonyme, an association dedicated to "the study and promotion
of MODERN ART"[12] through publications, lectures, and exhibitions. Dreier presented
Klee in group shows in 1921 and 1923 and gave him his first solo exhibition in New
York in 1924 at her galleries on Fifty-seventh Street.

In 1930 Klee became the first living European painter to be accorded a retrospective
at the Museum of Modern Art. Comprised of over sixty-three paintings from 1919 to

1930, the exhibition brought to light Klee's extraordinary fecundity and technical and stylistic range. As Alfred H. Barr, Jr., wrote in the accompanying catalogue, "Nothing is so astonishing to the student of Klee as his infinite variety."[13]

Another German crusader, Emmy (known as Galka) Scheyer, moved to America in 1924 and spent the next twenty years promoting Lyonel Feininger, Alexej Jawlensky, Kandinsky, and Klee through exhibitions and lectures on the West Coast. Believing that a collective presence would draw more attention to the artists and the mutual spiritual foundations of their work, she identified the group as the Blaue Vier (Blue Four), in homage to their earlier association with the Blaue Reiter (Blue Rider) group.

In early 1927 Baroness Hilla Rebay von Ehrenwiesen, yet another impassioned German apostle of Modern art, arrived in America.[14] Rebay, like her compatriots Dreier and Scheyer, was an artist. As Carolyn Lanchner has written: "Rebay combined Dreier's faith in the spiritual power of art with Scheyer's social abilities, and was perhaps the most effective of the three."[15] Rebay was committed above all to non-objectivity in art.[16] She met Solomon R. Guggenheim, an industrialist and patron of the arts, and became his adviser. Beginning in 1929 she introduced Guggenheim to the most progressive European artists, in particular Kandinsky. Under her guidance, Guggenheim collected art (eventually purchasing over 150 works by Kandinsky) and later founded the museum that now has his name, making Rebay the first director.

Guggenheim began to collect Klee's work in the 1930s, although the exact nature of the relationship of Rebay and Guggenheim to Klee is not entirely clear. Certainly Rebay would have been familiar with Klee's oeuvre from exhibitions in Germany, particularly those at Herwarth Walden's Der Sturm gallery, where Rebay herself had exhibited as early as 1917. In addition, we know from Kandinsky's widow, Nina, that when Rebay and Guggenheim visited them at the Dessau Bauhaus in 1929, they also went to the neighboring studio of Klee. Klee later reported to the Kandinskys that he had said to the baroness: "Since I believe you are interested only in abstract art, you will not find anything among my pictures."[17] As Louise Averill Svendsen notes:

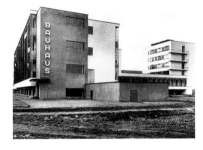

The Dessau Bauhaus, designed by
Walter Gropius, 1925–26.
Bauhaus-Archiv, Berlin. Photo Lucia Moholy.

> Miss Rebay's disdain for figurative art and passion for the non-objective were legendary. "Paintings with an Object" were listed separately, unillustrated in the back of her exhibition catalogues of the Collection, with an explanation that they "were collected to present outstanding artists whose works led to non-objectivity." Yet her prejudices never seemed to deter her critical eye, and, as we have seen, she continued to buy Klee's paintings although she rarely exhibited them. Certainly she considered him a friend. On the cover of a book . . . in her library she has written, in her emphatic scrawl, "Some personal *Art History*," and after the names of artists listed within, has inserted capsule designations. Domela is

described as "friend in Paris;" Duchamp as "friend also in Paris;" Kandinsky as a "good friend," but she singles out Klee as "old friend."[18]

In tracing the origins of the Guggenheim Museum's Klee holdings, we find that the first example the museum acquired, *Tropical Gardening* (1923, cat. no. 31), was purchased by Guggenheim either through or from Rudolf Bauer, a Berlin-based painter and Rebay's longtime lover. Guggenheim gave the watercolor to the newly established Solomon R. Guggenheim Foundation in 1937, and soon thereafter began plans to build a museum to house his expanding collection. He also acquired *Dance You Monster to My Soft Song!* (1922, cat. no. 25) from Bauer (it originally belonged to the St. Annen-Museum in Lübeck and was banned by the German government as "degenerate art") and gave it to the museum in 1938. That same year Rebay, as director, purchased *Tree Culture* (1924, cat. no. 36) and *Owl Comedy* (1926, cat. no. 42) from Bauer. She had a number of works by Klee in her own possession as well, and the museum obtained several of them either during her lifetime or from her estate in 1971. Among this group was *Park near B.* (1938, cat. no. 71), which bears the artist's inscription, "Für Hilla Rebay—in Freundschaft" (for Hilla Rebay—in friendship).

By far the most significant group of Klees to enter the Guggenheim Museum's collection came through the estate of Karl Nierendorf. Nierendorf, a German art dealer who in the 1920s championed German Expressionism in Europe, must also be counted among the pioneering dealers (along with J. B. Neumann, Curt Valentin, and Marian Willard) who brought Klee's art to the attention of the American public. He arrived in New York in 1937 and for ten years served as Klee's leading dealer there, holding regular exhibitions at his Fifty-seventh Street gallery.[19] Nierendorf also furthered Klee's reputation by writing a lavishly illustrated monograph on the artist in English in 1941 and by publishing in 1944 the first English translation of Klee's *Pedagogical Sketchbook*, an enormously important compilation of Klee's concepts in formal theory, which he taught at the Bauhaus. When the dealer died in 1947, the Guggenheim Foundation acquired his entire estate of 730 objects. Among them, the most spectacular by far were Klee's 121 works, some of which Nierendorf had obtained directly from the estate of the artist.[20]

Nierendorf's Klees were not all of equal quality. In the 1960s and 1970s, through the efforts of Guggenheim director Thomas Messer, a number of them were deaccessioned in order to acquire several of the artist's major oils, which measurably strengthened Klee's representation in the museum's collection. Of particular importance were the enchanting *Night Feast* (1921, cat. no. 20), purchased in 1973, and two important geometric oil paintings that exemplify the artist's interest in mathematics and music: *In the Current Six Thresholds* and *New Harmony*, acquired in 1967 and 1971, respectively.

Solomon's niece Peggy Guggenheim, herself a patron of the arts and a dealer,

amassed an extraordinary collection of Cubist, Surrealist, and Abstract Expressionist work. Her collection, which remains permanently housed in her palazzo in Venice, joined the Guggenheim Foundation in 1976, adding two more Klees to its holdings. *Portrait of Mrs. P. in the South* (1924, cat. no. 34) was a gift to Peggy from Nierendorf in 1941, and the Bauhaus-period *Magic Garden* (1926, cat. no. 40) was purchased by her from D.-H. Kahnweiler in 1938. In the 1942 opening of Peggy's Art of This Century gallery in New York the works were included mounted on a mechanized belt in one of Frederick Kiesler's highly dramatic, revolving installations.

Paul Klee's studio at the Weimar Bauhaus, 1925.

The Guggenheim's most recent Klee acquisition has come through the generosity of two of the institution's most important benefactors, Justin K. and Hilde Thannhauser. Klee's association with the Thannhauser family dates to 1906, the year the artist took up residence in Munich. Justin's father, Heinrich, had founded the Moderne Galerie in that city and in 1911 showed thirty drawings by Klee. This was one of the artist's earliest exhibitions. Klee also saw the first show of the Blaue Reiter group at Thannhauser's gallery in December of that year. He was particularly impressed by Robert Delaunay's paintings, which greatly inspired the development of color in his oeuvre. A few months later Klee participated in the second Blaue Reiter exhibition, at the Galerie Hans Goltz.

In 1963 the Guggenheim Foundation received a portion of Justin Thannhauser's magnificent collection of Impressionist, Post-Impressionist, and Modern French masterpieces.[21] When Hilde died almost thirty years later, she bequeathed to the museum an additional ten works, including Klee's playful watercolor *Jumping Jack* (1919, cat. no. 14). It is one of a series of many drawings he executed in the early 1920s on the theme of masks, puppets, and the theater.

Paul Klee at the Guggenheim Museum is the first publication to unite all the works by Klee from the holdings of the Solomon R. Guggenheim Foundation since the addition of the Peggy Guggenheim and the Thannhauser collections. As such it is an essential source on Klee's art. It is published on the occasion of the eponymous exhibition at the Guggenheim Museum SoHo, most of the works of which will travel for a showing in Madrid at the galleries of the Banco Bilbao Vizcaya. In the essay that follows this introduction, Andrew Kagan discusses Klee's stylistic development, drawing on key examples from the Guggenheim collection to illuminate his ideas. Dr. Kagan, the author of *Paul Klee: Art and Music* (1983), writes from his perspective as a critic and professor of art, music, and architecture.

It should be noted that this volume does not transcribe Klee's inventory numbers and descriptions from his *Oeuvrekatalog*, nor does it include information about signatures, inscriptions, or complete provenance. Most of this data, which is still being

compiled and revised, appeared in Louise Averill Svendsen's catalogue of the 1977 exhibition *Klee at the Guggenheim Museum*. Angelica Zander Rudenstine, former Research Curator of the Guggenheim, published her meticulous documentation of the Klee oils in the two-volume *The Guggenheim Museum Collection: Paintings 1880–1945* (1976). Vivian Endicott Barnett's precise study of the works on paper, including conservation analysis, provenance, and publication and exhibition histories, has been started with a grant from the Mellon Foundation. These investigations, along with updated research and interpretive texts by the Guggenheim's curatorial staff and outside scholars, will be the subject of a new edition of *Klee at the Guggenheim Museum*. The book will offer an exhaustive study of Klee's production in all mediums as the inauguration of a series presenting focused scholarship on those artists represented in-depth in the Guggenheim collection.

In addition, the collection-in-depth of Paul Klee at the Guggenheim will continue to be reexamined and reinterpreted in exhibitions and catalogues such as the present one. Klee's relevance to a museum of Modern and contemporary art, and to the Guggenheim's holdings in particular, cannot be overstated. His work establishes a dialogue not only with artists of his generation like Kandinsky, but also with myriad others who shared an affinity with or were influenced by his art and teachings. For example, Joan Miró's *The Tilled Field* (1923–24), a painting in the Guggenheim's collection, relies very much on Klee's disposition of figures in space for its overall compositional approach. In another case, Josef Albers, who is represented in the collection by over thirty examples, was a pupil of Klee's at the Bauhaus.

Critics today continue to find new ways of reading Klee's work. Like many of the great artists of the early twentieth-century avant-garde, Klee anticipated in his work later thinking. In particular, certain approaches and attitudes he adopted prefigure those of numerous movements in postwar American art, including Abstract Expressionism, Color-field painting, and Minimal and Conceptual art. Klee's plurality of styles, his methods of relating form and content, his belief in the importance of process, and the incorporation of language into his art provide ample substance for a reinvestigation of his significance and influence in light of contemporary developments.

Klee, like many of the great artists of the 1950s, believed that formal elements, such as line, color, and material, were themselves carriers of meaning. Yet Klee also repeatedly stated that the objective in art is not form, but form-making. In a notebook entry, he wrote, "The act of giving form determines form itself and the process is more important than the form."[22] This recognition of the significance of process was adapted in the late 1960s by a generation of artists who relied on process and the properties of materials as determining factors in the creation of their work. Klee saw the potential of experimentation with traditional materials in nontraditional combinations. He

imparted a quality of ephemerality to his works by virtue of the incompatibility of these mixtures that is akin to technical strategies used by artists of the post-Minimal generation. Furthermore, Klee acknowledged the temporal aspect of his painting. He understood not only that time is linked to process, but also that the recurrent image, continually transformed or reconstructed, needs to be read in time as well as space— simultaneously as well as successively. And finally, the notational vocabulary of glyphic forms that is integral to Klee's pictorial conception has been used by painters since the beginning of the century to extend both the abstract and representational possibilities of the image. Klee, who was influenced by Cubism, Dada, and Surrealism, expanded the possibilities of linking word and image, blending poetry and humor in provocative combinations. The ensemble of the Guggenheim's Klee collection offers great possibilities for understanding the artist's unique ability to communicate within the context of his own historical time, as well as in the present.

1. For Klee's theory see his Bauhaus lectures and articles, which are reprinted in *Pädagogisches Skizzenbuch*, *Bauhausbücher* 2 (Munich: Albert Langen, 1925); translated as *Pedagogical Sketchbook* (New York: Nierendorf Galleries, 1944). His writings comprise more than 3,000 pages of notes and drawings and appear in Jürg Spiller, ed., *Das bildnerische Denken* (Basel and Stuttgart: Benno Schwabe, 1956); translated by Ralph Manheim as *Paul Klee, the Thinking Eye: The Notebooks of Paul Klee* (London: Lund Humphries, and New York: George Wittenborn, 1961). His letters and diary entries were published by his son in Felix Klee, ed., *Tagebücher von Paul Klee, 1898–1918* (Cologne: M. DuMont Schauberg, 1957); translated by Max Knight, Pierre B. Schneider, and R. Y. Zachary as *The Diaries of Paul Klee, 1898–1918* (Berkeley and Los Angeles: University of California Press, 1964). They also appear in Felix Klee, ed., *Paul Klee: Leben und Werk in Dokumenten* (Zurich: Diogenes, 1960); translated by Richard and Clara Winston as *Paul Klee: His Life and Work in Documents* (New York: Braziller, 1962).

2. Harold Rosenberg, "Art as Thinking," *The New Yorker* 43, no. 5 (March 25, 1967). Reprinted in Rosenberg, *Artworks and Packages* (New York: Horizon Press, 1969), pp. 50, 55.

3. It is interesting to compare the derivation of Kandinsky's titles with that of Klee's. As Vivian Endicott Barnett tells us, the titles *Improvisation*, etc., to which numbers and sometimes subtitles were assigned, were impersonal, nonspecific, abstract categories based on musical terminology. See Barnett, *Kandinsky at the Guggenheim* (New York: Solomon R. Guggenheim Museum and Abbeville Press, 1983), p. 26. Klee was an extremely inventive creator of titles. The relationship between word and image was something he cared about deeply, and his designations often enhanced a work's narrative associations. In addition to signing and dating each work, he inscribed it with a number and a title. He then entered this information, along with other classifications, into his inventory system, the *Oeuvrekatalog*.

4. Barnett, *Kandinsky at the Guggenheim*, pp. 102–07. For the related watercolors and up-to-date information see also Barnett, *Kandinsky Watercolours: Catalogue Raisonné 1900–1921* (London: Sotheby's Publications, 1991).

5. Rosenberg, *Artworks and Packages*, pp. 50, 55.

6. In the essay in this catalogue, Andrew Kagan discusses Klee's oeuvre as an "art of ultimate synthesis."

7. As further evidence of the influence of time and context on the readings and criticism of the artist's work, compare the following from Hilton Kramer (cited in Gert Schiff, "Paul Klee at the Guggenheim," *Artforum* 5, no. 9 [May 1967], pp. 49–52) with the 1967 article by Rosenberg cited earlier in this essay:

> Despite its beauty, its incredible richness and its worldwide influence, Klee's work still meets with various misunderstandings as to its character and rank. Twenty years ago, during the heroic phase of Abstract Expressionism, his critics were still inclined to minimize Klee by calling him a miniaturist, as had been done now and then during his lifetime. . . . Nowadays, the bias is more against the representational, or hieroglyphic, elements in Klee's art: obsolete in themselves, they are said to be the outgrowth of a "conservative" philosophy and of Klee's stubbornly maintained "loyalty to the conventions of romantic illustration."

8. In 1977 the Guggenheim Museum mounted an exhibition and published a catalogue based on the Klees in the collection: *Klee at the Guggenheim* (New York: The Solomon R. Guggenheim Foundation, 1977). In this publication (p. 20), Thomas Messer noted the absence of watercolors inspired by the artist's North African journey.

9. Heinz Berggruen, "Some Stations on My Klee Itinerary," in Sabine Rewald, *Paul Klee: The Berggruen Klee Collection in The Metropolitan Museum of Art* (New York: The Metropolitan Museum of Art, 1988), p. 9.

10. Carolyn Lanchner, "Klee in America," in Carolyn Lanchner, ed., *Paul Klee* (New York: The Museum of Modern Art, 1987), pp. 83–111.

11. Discussing only briefly Klee's introduction to America, this essay focuses particularly on his relationship to the "Guggenheim family"—the museum's founders, directors, and benefactors. For a complete discussion of Klee in America, see Lanchner, "Klee in America."

12. Quoted in Lanchner, "Klee in America," p. 86.

13. Ibid., p. 94. A topic both Lanchner and Kagan explore is Klee's considerable influence on American art. In addition to Lanchner, see Kagan, "Paul Klee's Influence on American Painting," parts 1 and 2, *Arts Magazine* 49, no. 10 (June 1975), pp. 54–59, and 50, no. 1 (Sept. 1975), pp. 84–90.

14. Lanchner, "Klee in America," p. 93.

15. Ibid., p. 90. Lanchner emphasizes the different motives and philosophies of Scheyer and Dreier:
> Scheyer's projects were undertaken, Klee had written to Dreier in June 1923, not as a dealer, but out of love of art; while this certainly gave her common cause with Dreier, she had little of the American's earnest belief in the efficacy of art to uplift society. For Scheyer, art's proper sphere was much more with the cultural and economic elite, and it was principally this world she cultivated in proselytizing for her Blue Four.

16. Rebay derived the term "non-objectivity" from the German word *gegenstandlos* (which means literally "without object"). It came to mean for her a type of abstraction based on the unity of aesthetic and spiritual principles.

17. We know that Rebay did purchase work directly from the artist, including *Inscription* (1926), which she bought in 1930 and transferred to Guggenheim in 1938, and which he gave to the collection in 1941.

18. Louise Averill Svendsen, "Notes on Klee," in *Paul Klee, 1879–1940, in the Collection of the Solomon R. Guggenheim Museum, New York* (New York: The Solomon R. Guggenheim Foundation, 1977), p. 7.

19. Svendsen discusses the historical relationship between Nierendorf and Klee. In 1923, when Nierendorf opened his gallery in Berlin, Klee was under contract to Hans Goltz in Munich. Alfred Flechtheim, who had galleries in Düsseldorf and Berlin, took over Goltz's contract with Klee after 1925, and maintained the relationship until he was forced to flee Germany in 1934. D.-H. Kahnweiler was next in the succession of Klee's dealers. Svendsen writes: "We have no idea of what arrangements, if any, Nierendorf made with Klee after he opened his gallery in New York. For reasons not yet clear, almost none of Nierendorf's records—his correspondence, receipts of purchase and sales—of the period of his American residence came to the Museum with the Estate," in Svendsen, "Notes on Klee," p. 7.

20. We know this from a letter Nierendorf wrote to Rebay in December 1946, in which he says that he is bringing back many Klees from his trip to Europe. In 1947 the Nierendorf Gallery presented an exhibition of these works entitled *A Comprehensive Exhibition of Works by Paul Klee: From the Estate of the Artist*. Included in the group were *The Bavarian Don Giovanni*, *Runner at the Goal*, *Contact of Two Musicians*, and *Boy with Toys* (all in this catalogue).

21. The collection was placed on permanent loan to the Guggenheim in 1963 and was legally transferred to the foundation after Justin Thannhauser's death in 1976.

22. Jürg Spiller, ed., *Paul Klee, Notebooks, Volume 2: The Nature of Nature* (New York: George Wittenborn, 1973), p. 43.

KLEE'S DEVELOPMENT

Andrew Kagan

Paul Klee came into the world as a graphic artist, a draftsman, an illustrator in line. By the time he left, he had created some of the greatest masterworks of pure color painting in history. Klee's metamorphosis from draftsman to painter, from caricaturist to colorist forms one of the most interesting stories of twentieth-century art. It is, in some respects, a typical tale of the victory of commitment, patience, and quiet perseverance. But it is also an unusual story of an artist's slow, deliberate transformation of his creative personality. Klee narrated much of this saga as it unfolded, in the eloquent and entertaining diaries he kept from 1898 to 1918,[1] a seminal epoch in the development of what we still call Modern art.

Klee was born in Bern, in northern Switzerland, in 1879. From his infancy, he was encouraged in his aptitude for drawing by his maternal grandmother. By the age of fourteen he had already mastered the basic techniques of linear illustration. Many landscape drawings and copies from postcard, calendar, and travel-book illustrations have come down to us from Klee's boyhood (for example, *Gemmi Pass, Valais Alps*, ca. 1895, cat. no. 1; *Hilterfingen*, 1895, cat. no. 2; and *Thunersee near Schadau*, 1895, cat. no. 3). These sketches bear witness to Klee's precocious understanding of line and its ability to suggest volume, atmosphere, and space. But as a child growing up in the German-speaking part of Switzerland, Klee was also steeped in the Germanic tradition of graphic illustration, which often emphasized the macabre, the bizarre, and the grotesque. This tradition originated in the Middle Ages and survived in the work of the late-nineteenth-century artists Arnold Böcklin, Ferdinand Hodler, and Franz von Stuck, who were the best-known contemporary artists in Klee's Swiss-German milieu.

By the age of sixteen, Klee had discovered in himself a talent directly related to this illustrative tradition, a talent for drawing caricatures and satirical cartoons. Caricatures, grotesques, and humorous doodles fill the margins of his school notebooks. One particularly amusing example appears in Klee's geometry notebook for the year 1898, his last year at the gymnasium, the upper-level high school. On the staff lines drawn at the upper-right-hand margin of a page we find the two opening measures of Beethoven's Fifth Symphony—the familiar, dramatic "fate" motif. Above the fourth

Facing page: Josef Albers, *Klee Dessau XI '29*, 1929. Photocollage, 29.5 x 41 cm. The Museum of Modern Art, New York. Courtesy The Josef Albers Foundation, Inc., Orange, Conn.

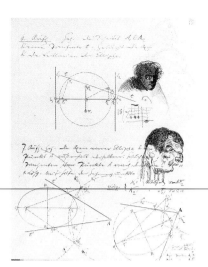

"The Eye of Beethoven," page 154 from Paul Klee's school notebook for analytic geometry, 1898. Pen and ink and pencil on paper, 23 x 18.5 cm.

Felix Klee Collection, Bern.

note is the fermata, the musical symbol for discretionary sustain. And directly above the eyelike fermata there appears the glowering, imperious eye of Beethoven, shrouded in shadow, imagined by the young Klee in a kind of punning, humorously loving caricature. Evidently, Klee was far more absorbed in these clever drawings than in his schoolwork, for he only barely managed to pass the final exams for his diploma. "Four points more than the minimum passing grade," he confessed in his diary. "After all," he wrote with characteristic irony, "it's rather difficult to achieve the *exact* minimum, and it involves risks."

In the autumn of 1898 the nineteen-year-old Klee went off to Munich to study art, principally with von Stuck. He excelled in drawing and found his main creative outlet in satire. In the domain of color, he repeatedly wrote, he found it very hard to make progress. "During the third winter," he recalled, "I even realized that I probably would never learn how to paint." It is strange to observe that although Klee eventually became one of the foremost masters of color, he had, unlike Pierre Bonnard, Robert Delaunay, or Henri Matisse, almost no natural gift for it. For fifteen years he grappled with basic problems of color and then for another five years with more advanced problems. Every step forward was, for him, the result of a difficult struggle. He had, as he put it, to begin "before the beginning."

Klee is well known as an artist of quiet humor, poetic wit, and modest irony. But to understand Klee fully it is necessary to understand that he was also a highly ambitious, historically conscious idealist who yearned to believe in the ultimate importance of painting. In his youth, however, frustrated idealism turned into bitter cynicism. His early diaries reveal a young man shifting precariously between conviction and doubt, viewing himself sometimes as a "kind of Prometheus" who "struggled with the godhead," and at other times as a mere satirist, a pessimistic, acid-penned illustrator. A diary entry of 1900 states, "From time to time I collapsed completely into modesty, wished to produce illustrations for humor magazines. Often I said that I served Beauty by drawing her enemies caricature and satire. But that is not enough. I must shape her directly with the full strength of my conviction. A distant, noble aim." In the following year, Klee lamented, "I am again all on the side of satire. Am I to be completely absorbed by it once more? For the time being it is my only creed." He asks anxiously, "Shall I never become positive?" Around this time, Klee actually did submit satirical drawings to several humor magazines, with the thought of becoming a professional cartoonist. Fortunately, all these efforts were rejected.

Drawing was to Klee almost as natural as breathing, and it remained essential to him throughout his life. As the principal instrument of his "original realm of psychic improvisation," his feeling for line was a resource that he could never renounce or relinquish. More than half of Klee's art works, that is, more than 4,500 of approxi-

mately 9,000 objects, are plain line drawings. If you look through his complete work you will discover thousands of bizarre, amusing cartoons, doodles, and grotesques. But Klee was acutely aware that his scratchy, fragile, nervous line, though original, was not an instrument of grandeur, and that cartoons and doodles could not be masterworks on the historic, grand scale. Moreover, he felt a profound dissatisfaction with his native impulse toward the grotesque. His dream of becoming a great artist, his "distant noble aim" of shaping beauty with positive conviction, was above all a dream of mastering the art of color. It was in color that he placed his highest hopes and ambitions, his aspiration to historic stature as an artist. A diary entry from Klee's Italian journey of 1902 gives us some idea of the great weight he hoped color might someday carry for him. Marveling at the rich colors of nature in the Roman Campagna, Klee rhapsodized, "There is moral strength in such color. I see it just as much as others do, I too shall be able to create it someday. When?" He sadly realized "that a long struggle lies in store for me in this field of color." Yet at the same time he could see that he would eventually need to find "the style which connects drawing and the realm of color" and so, as he put it, to "find a place" for his line.

Following his trip to Italy Klee returned to Bern, where he lived for the next four years. At first he made progress only in graphic art, cultivating the line that he called "his most personal possession." Between 1902 and 1905 he employed this line in creating *Opus One*, the suite of twelve satirical etchings that he regarded as his first significant, original product (see *Aged Phoenix {Invention 9}*, 1905, cat. no. 8, and other examples in this catalogue). Again, Klee was disturbed by this impulse toward satire. He had fallen heir to some of the same sense of alienation that had driven such painters as Vincent van Gogh and Paul Gauguin to repudiate their cultural and social milieu. This feeling had acted powerfully to alter the traditional assumptions and purposes of many artists. The most progressive among them could find little in their own society worthy of overt praise or even objective documentation. To find sanction, justification, and inspiration for an art of satire and censure, Klee consulted the work of Honoré Daumier, James Ensor, and Francisco de Goya, but he remained unsatisfied. He said that he "yearned to become serious and better." But when he viewed the world around him, he could feel only critical and negative. In truth to his own nature, he continued on this path, albeit with some reluctance. In the inventive work *Two Gentlemen Bowing to One Another, Each Supposing the Other to Be in a Higher Position (Invention 6)* (1903, cat. no. 4), Klee demonstrated his growing facility in the craft of zinc-plate etching, while acidly lampooning the servility of his fellow citizens and the ritualistic hierarchy of their society.

In general, during the first decade of the century Klee had many difficulties and few successes. Living in Munich after his marriage to Lily Stumpf in 1906, he was investing

most of his professional energies in modest, methodical experiments in the use of color. His wife gave piano lessons to support their household, which from late 1907 included their son Felix.

In 1910, having reached the age of thirty, Klee lamented that "I cannot say that the survey is a cheering one at this time, for I am still incapable of painting." But soon things started to look up. He began to learn from the paintings and writings of van Gogh and especially of Paul Cézanne, whom he labeled his "teacher par excellence." In 1911 he met Vasily Kandinsky, his neighbor in Munich, who was already far more advanced than Klee as both a painter and a theorist. The two artists eventually became lifelong friends and mutual influences.

Then, at the historic first Blaue Reiter (Blue Rider) exhibition, organized by Kandinsky and Franz Marc in December 1911, Klee encountered paintings by Delaunay, who was to become his main source of inspiration. Klee was so impressed by the young Frenchman's work that he arranged to visit Delaunay in his Paris studio in 1912. There Klee saw his new *Simultaneous Window* paintings, which he immediately recognized as the most innovative, advanced art being created at the time. Klee wrote a review of Delaunay's work, calling him "one of the most brilliant individuals of our age," and he translated into German Delaunay's theoretical essay "On Light."

As Klee began to assimilate these new lessons, his outlook gradually brightened and small successes came in his work. And as his pure painterly abilities grew, his impulse to parody, caricature, and satirize diminished. This transformation is suggested in the 1913 painting *Flower Bed* (cat. no. 9), where a growing feeling for color and surface structure have started to supplant his tendency toward illustration.

In 1914, the cataclysmic year when World War I began, Klee took a pivotal journey to North Africa with his colleagues August Macke and Louis Moilliet. Painting there alongside Macke in a manner derived from Delaunay's *Simultaneous Window* pictures, Klee was at last able to declare, "Color and I are one. I am a painter." This was a momentous occasion for the thirty-five-year-old artist. Soon afterward he spoke of "deserting the realm of the here and now to transfer one's activity into a realm beyond, where total affirmation is possible."

With the help of Delaunay Klee found a personal pathway into the art of color painting and a personal connection to Parisian Modernism, which was the international standard of high art. And in the transparent color depths of what Delaunay labeled "pure painting," Klee discovered both an escape from his Germanic tradition of graphic illustration and a path out of satire toward affirmation. He began in his Tunisian watercolors of 1914 to use a grid to structure his compositions. This helped him break down color and natural forms into discrete units, like individual notes in music, which he was then able to handle more logically, effectively, and consistently.

Robert Delaunay, *Simultaneous Windows*
(*2nd Motif, 1st Part*), 1912.
Oil on canvas, 54.9 x 46.4 cm.
Solomon R. Guggenheim Museum,
Gift, Solomon R. Guggenheim 41.464A.

In the following year, 1915, Klee began to conceive of the pictorial grid in a new way. The Cubists, such as Pablo Picasso and Georges Braque, and the Orphists, such as Delaunay, had been using the grid as a device for breaking down and organizing views of space and the objects within that space; this was, in essence, a modern version of the Renaissance perspective grid. Klee now began to interpret the grid as a flat composition of color rectangles, without any reference to the visual world at all, and hence without any need for critical commentary.

The idea of the flat color-rectangle composition was being developed by several European artists around this time. The Russian Kazimir Malevich had introduced his flat Suprematist compositions in 1913–14. In Holland Piet Mondrian and Theo van Doesburg joined in this trend after 1916–17 with their De Stijl theories and paintings. Klee, like his countryman Jean Arp and Arp's wife Sophie Taeuber, first responded to these aesthetic currents in 1915. The international movement toward flat color-rectangle composition well served Klee's main hopes and ambitions. It provided him with a structured approach to color and helped free his use of color from the problems of improvisatory drawing, symbolic form, and pictorial space. It therefore allowed

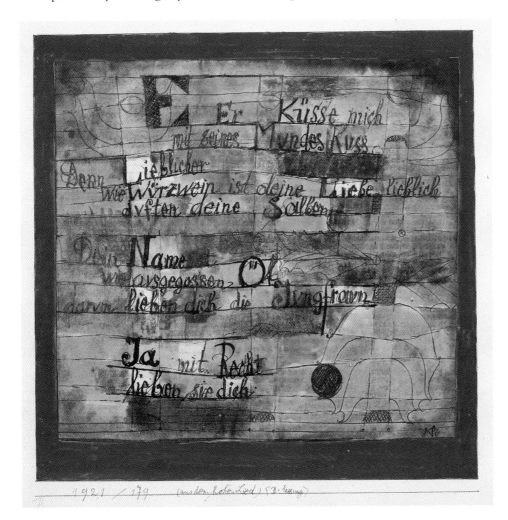

Paul Klee, *From the Song of Songs "Let Him Kiss Me with the Kisses of His Mouth" (II Version)*, 1921.
Ink and watercolor on paper, bordered with watercolor on the cardboard mount, paper 16.2 x 17.4 cm; paper and border 19 x 19.4 cm; cardboard 27.4 x 27.4 cm.
Solomon R. Guggenheim Museum 48.1172x535 (cat. no. 18).

25

Klee's color sense and paint handling to develop independently, without interference from other pictorial concerns. In some remarkable experiments of 1916, the artist moved closer to his own definitive approach to the color-rectangle composition. As we see in *From the Song of Songs "Let Him Kiss Me with the Kisses of His Mouth" (II Version)* (1921, cat. no. 18), a later example, he began to set his own poems and other texts to color, as texts are set to music. The novelty of these *Lieder* or art song pictures, which Klee produced occasionally through 1921, has tended to obscure their significance. His use of flat, rectangular color units as a setting for words shows how strongly he had come to equate such units with musical notes and, consequently, that he was beginning to view composing with color rectangles as analogous to composing melodies or themes in music. No longer merely a clever illustrator in line, Klee now set out to become a composer in absolute color.

In 1919 Klee produced what might be considered his first true color-rectangle composition, *With the Green Rectangle*. As the straightforward title suggests, the painting contains no caricature, no irony, no illustration. It is an experimental effort at pure, painterly affirmation. Klee's progress as a painter now began to reap rewards. For the first time, his dealers were able to sell enough of his work so that he was able to support himself and his family through his art. Then, late in 1920, he was invited to teach at the new Bauhaus in Weimar, Germany.

The year 1921, when Klee began teaching at the Bauhaus, marked the threshold of his full maturity as a painter. By 1923–24, he had attained comprehensive mastery of color. In subsequent years he explored every register, tone, and nuance of color, every dominant and evanescent sensation. He came to excel in the subtle arrangement and modulation of tones and harmonies. He experimented constantly and developed many original painting techniques. He used brush, spray gun, and knife. He worked in watercolor, gouache, pastel, casein, oil, and tempera, which he glazed, impastoed, scrawled, smeared, splattered, stained, and poured onto canvas, burlap, muslin, linen, gauze, cardboard, hardboard, metallic foils, upholstery fabric, wallpaper, fine papers, coarse papers, and newsprint.

Klee's greatness as a colorist and his gifts as a draftsman embrace a truly extraordinary range and diversity. His seemingly tireless experimentation and his astounding inventiveness are among his distinctive characteristics, but they make his mature work rather difficult to grasp and understand in its entirety. Klee may seem to be everywhere at once, with the most random approaches. It must be understood that his ultimate ambitions embraced the concept of an art that would resolve all apparent contradiction, an art that would reconcile all dualities and oppositions—in other words, an art of ultimate synthesis. "Truth," he declared, "demands that all elements be present at once." In this sense, the encyclopedic diversity of his oeuvre must be seen as pur-

poseful rather than as merely restless or undisciplined. It is true that Klee frequently permitted himself to dash off the most casual, seemingly random minor works, but he also continually forced himself to grapple with the most difficult problems of art and theory. He implemented his visions both playfully and with methodical determination. He denied none of his creative impulses, large or small, in the hope that his art might eventually embrace the totality of his universe—a universe of mathematics and poetry, lowly commonplaces and lofty extremes, sober science and capricious fantasy.

In no area of Klee's art was his effort more methodical or his ambition more clearly focused than in his development of the color-rectangle composition. Of all his formats, the color-rectangle composition remained consistently nearest the center of his aesthetic purposes.

In 1923 Klee's rectangle compositions began to blossom into a new art of absolute color. Several of these paintings emphasize the idea of harmony in their titles—*Harmony of Squares* and *Harmony of Blue and Orange* (both 1923), *Alter Klang* (1925), *Harmony* (1927), and *New Harmony* (1936, cat. no. 66). Unlike Mondrian and van Doesburg, Klee conceived the color-rectangle composition not essentially as pattern, not primarily as construction, but rather as a theme or melody, just as the musical composers he most admired—Beethoven, Mozart, and Haydn—thought in thematic terms. We have seen how Klee came to view the color rectangle as comparable to the musical note, a building block that itself has no special meaning. In the flat color grid, whether truly rectilinear—as in *In the Current Six Thresholds* (1929, cat. no. 50)—or with the slight dynamic variations he usually preferred, he found a type of structure, like a musical staff, on which he could compose in color. His remaining problem was to determine just what an independent color theme might be; that is, what in painting could be analogous to a musical melody or theme—a sequence of notes that possesses an individual identity, a coherent, expressive unity. It was a problem somewhat akin to that confronted by a beginning music student trying to play a melody in such a way that it sounds like more than a succession of separate tones, more than a pattern, so that its special identity and expressive content come forth.

Historically, selecting a pictorial theme meant choosing a mythical, biblical, nature, or battle scene, a still life or model, and whether to depict in a realistic, poetic, or abstract manner. In his color-rectangle compositions Klee was attempting to define a new sort of enterprise; that is, how to order color units into a form with significant, evocative identity, an identity that transcends mere decoration, intellectual interest, and sensory stimulation. In his effort to replace traditional subject matter, Klee began to explore the internal problems and possibilities of the color theme—development, color harmony and key, dynamics and interval relationships, rhythm and movement. He did this with an eye toward conveying expressive content through an absolute,

rational structure, just as melody does in music. Through the concept of thematic color composition, Klee finally attained that "realm beyond," that attitude of positive conviction, the absolute affirmation toward which he had struggled for so long. To clarify just what all this meant in Klee's art, I would like to take a close look at two of his finest color-rectangle compositions, *Alter Klang* and *New Harmony*.

Alter Klang is not only the summit of Klee's achievement in color-rectangle painting; it is also one of his masterworks. Though small, this painting in oil on cardboard is a deeply moving image, powerful in the genius of its composition. It is a spectrum of evocations, ascending from the gloom of deep blacks and greens around the edges to a serenely hopeful interplay of pinks and rich yellows at the center. It is at once a paradigm of absolute pictorial construction and a definition of the possibilities of thematic color content and identity.

As is often the case in Klee's art, the title of this work offers clues to the multiple levels of thought, purpose, and experience with which he invested it and that help it succeed visually. *Alter Klang*, meaning literally "old sound," is a German musical idiom with no precise English translation. It suggests, in a very general sense, concepts

of melody, harmony, and tonality that prevailed in Europe between the Renaissance and the nineteenth century. These were the concepts Klee most loved in music. He appropriated the idiom for this composition because he was working with concepts of color harmony, tonality, value, chiaroscuro, and thematic development that prevailed in painting during the same epoch.

Indeed, in *Alter Klang* color and light themselves form Klee's subject. They act as autonomous agents, molding a quietly haunting chiaroscuro—a chiaroscuro not of volume or physical space, but rather of vision alone. Gone are the narrative and representational symbols that made these pictorial devices meaningful in earlier times. The absolute, relatively neutral forms of the rectangles supplant natural contours or figures as the boundaries between different colors.

Klee was deeply involved with the affective power of light, especially light created by the dynamics of color interaction. We recall that he had, thirteen years earlier, chosen to translate Delaunay's essay "On Light." In *Alter Klang*, as in many of his color compositions, the overall effect is that of light passing through stained glass. Although a broad range of local colors is used, the picture is keyed, almost atmospherically, to a dominant green tonality. Klee often achieved such effects of light and atmosphere with transparent washes of color. In *Alter Klang* and other works that employ more-opaque paints, however, his rich velvety textures result in part from the use of dark underpainting, a technique he borrowed from the Old Masters.

Atmosphere, light created by color contrast and dynamics, dark underpaintings, and other traditional qualities and techniques form essential differences between Klee's rectangle compositions and those of the Mondrian–van Doesburg school. The artists of the De Stijl movement applied colors flatly over plain white grounds and used heavy lines to enclose the colors and restrict their interaction. These artists were also more self-consciously radical and revolutionary in their outlook than Klee. The latter was at times deliberately historical and eclectic, finding value in art of the past and attempting to synthesize certain traditional concepts with twentieth-century idioms and practices. Another difference lies in the often wavy lines of Klee's color grids, which give them a certain dynamic or emotive impulse. "Pathos," Klee said, "is expressed in art as a motor impulse of the vertical, or as denial or disruption of the vertical." A very understated feeling of striving or yearning—what Klee called "cool Romanticism"—is a distinctive component of *Alter Klang*, with the subtle deviation of its grid from absolute rectilinearity.

Another distinguishing element of his work is the irregular sizes and shapes of the color squares. These irregularities provide a humane, almost childlike playfulness, which is as typical of Klee as it is of his favorite composer, Mozart.

New Harmony, of eleven years later, is one of the last of Klee's thematic color-rectan-

Paul Klee, *Alter Klang*, 1925.
Oil on cardboard, 38 x 38 cm.
Öffentliche Kunstsammlung Basel,
Kunstmuseum.

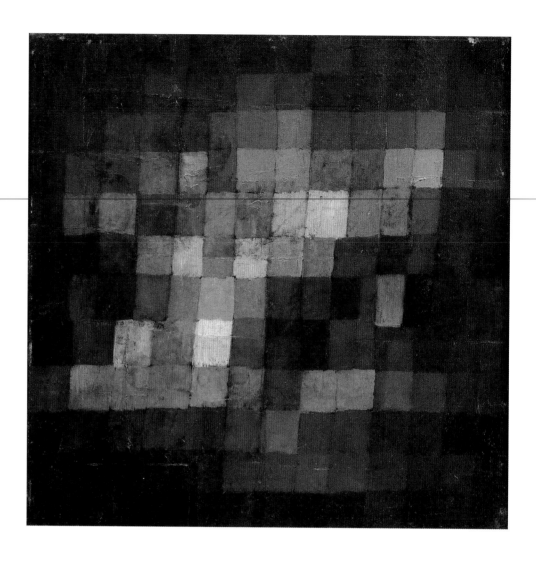

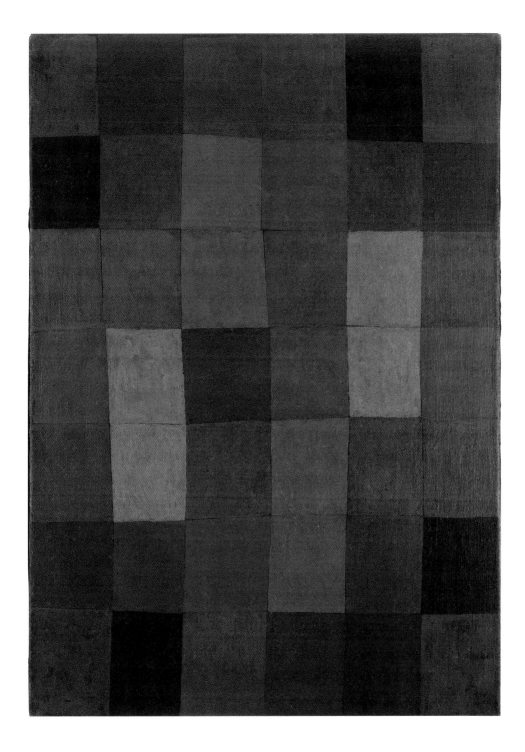

Paul Klee, *New Harmony*, 1936.
Oil on canvas, 93.6 x 66.3 cm.
Solomon R. Guggenheim Museum 71.1960
(cat. no. 66).

gle compositions and is second in quality and importance only to *Alter Klang*. It is a late, retrospective work, for the most part harking back to the artist's color thinking of the 1920s. The color is softened and textured by black underpainting. There are the playful irregularities of the color squares and the vertiginous undulations of the grid lines. Yet Klee must have felt or intended there to be specific points of contrast between his *New Harmony* and his "old harmony," *Alter Klang*. What did he consider to be new about *New Harmony*?

The most obvious difference is the heightened chromaticism of the later work: along its central axis are arrayed dissonant (that is, noncomplementary) pairs of orange and green squares. Dismissed along with the more traditional color consonance of *Alter Klang* is the medieval stained-glass effect, with its anterior light source. But the most important change from *Alter Klang* is the disappearance of the idea of emergence and growth, as embodied in the chiaroscuro of the earlier painting. In *New Harmony* light is distributed more flatly and evenly across the surface. The development of the individually significant theme is replaced in *New Harmony*—as in much twentieth-century music and painting—by a more uniform distribution of compositional interest. *Alter Klang* develops with dramatic intensity from the edges toward the center; *New Harmony* is anchored firmly at each corner by squares of blue-gray and is tightened all around by a border of rhythmically alternating medium and dark values. This equal stressing of the image across the frame takes the emphasis off temporality—development in time—and promotes instantaneity—the total, immediate view.

The principle of bilateral inverted symmetry governs the compositional order of *New Harmony* and supplants the organizing principle of thematic development and continuity; that is, the right half of *New Harmony* is, in effect, an inverted mirror image of the left half. The cross-correspondence of color units and their respective weights, which oppose and balance each other, effects what Klee called a "dynamic equilibrium." The structural unity of *New Harmony* is founded on this equilibrium.

Klee had long recommended compositional mirroring to his students at the Bauhaus as an aid in bringing pictorial structures to life. However, his primary illustrative model had been the technique of contrapuntal inversion, as employed in eighteenth-century music. In the music of Mozart, Bach, Haydn, and the early Beethoven, polyphonic structures are used to temper the expressive content of individual themes and to carry thematic continuity through several voices. The simultaneous (above and below) layering of themes mitigates the temporal message of the individual theme. The true musical analogy to the sequential (left-to-right) mirroring in *New Harmony* is not to be found in the eighteenth century, but rather in the twentieth, specifically in the compositions of the Schönberg school, the Second Viennese School, which in the 1930s was the leading exponent of Modern music.

There can be little doubt that as Klee referred in *Alter Klang* to both old music and old painting, so he intended an analogy between *New Harmony* and the nonthematic, twelve-tone music of Arnold Schönberg and his disciples. In this monodic (not polyphonic) type of music the composer would begin by selecting a row of twelve notes, the tone row. The persistence of this row, which is serially repeated in inverted, retrograde (backwards), and retrograde-inverted forms and transpositions, is supposed to supplant tonality and thematic development as principles of coherence. It is surely significant in this connection that Klee used precisely twelve tones of color in *New Harmony* (excluding the neutral gray rhythm base and the black underpainting), and that he inverted the left-hand sequence of twelve colors for the right side. The tendency of much twelve-tone music to be brief and compressed makes the analogy with *New Harmony* even more pronounced.

There is, however, a certain paradox in this analogy. The color content of *New Harmony*—as opposed to its structure and light values—is in no genuine conflict with Klee's earlier color compositions. We see a tranquil, almost autumnal harmony in this work dating from late in Klee's life and career. There is none of the agitation we find in Anton von Webern's music or in the syncopated ecstasies of Mondrian's *Broadway Boogie-Woogie*. It is as if Klee wanted once more to demonstrate, or to satisfy himself in a partly humorous manner, that he could make any kind of color structure a vehicle for the sort of content he wished to express.

The rectangle format provided Klee not only with a major vehicle for pure color painting, but also with a crucial solution to the other central problem of his career—namely, how to "provide a place for his line," as he put it, within the context of painting. As Klee had already set verbal poetry to color by 1916, so he began around 1920 to use color squares (and other color formats) as a setting to accompany and elevate the whimsical poetry of his cartoonlike, and often childlike, drawings. In other words, he began simply to superimpose his drawings—the libretti—on the color compositions— the scores. I have termed these syntheses of color and drawing "operatic paintings," because they depend so literally on Klee's great passion for and understanding of opera and on the way in which the often slight libretti of opera are borne up by great music. Klee well understood how Mozart, through the operas he so delighted in creating, successfully spanned the breach between the intimate worlds of popular song, light romantic poetry, and childlike fantasy on the one hand, and the Olympian realms of his symphonies and concerti on the other. In the operatic compromise between low and high taste, between silliness and sublimity, Klee saw a chance for his wiry, delicate line and the curious images it yielded. Often these images were drawn directly from the iconography of opera, especially comic opera, and figures such as harlequins, acro-

bats, *hanswurst* clowns, singers, and dancers frequently appear on Klee's tiny, imaginary stages. For example, K. Porter Aichele has proposed that *Costumed Puppets* (1922, cat. no. 24) depicts a scene in Mozart's *Così fan tutte*, with the characters Despina, Dorabella, and Fiordiligi.[2]

The prototype for Klee's operatic paintings was *The Bavarian Don Giovanni* (1919, cat. no. 15). Mozart's *Don Giovanni* was Klee's favorite opera—the embodiment of opera to him—and he knew its score by heart. The story had fascinated him since childhood. He had almost completely internalized the format of its erotic fantasy, and the structure of Klee's erotic visions derived in large measure from this classic tale. For example, the artist mentions early in his diary a "Leporello catalogue" that he kept, recalling the list of Don Giovanni's carnal exploits kept by his servant Leporello: "A little 'Leporello' catalogue of all the sweethearts whom I didn't possess provides an ironic reminder of the great sexual question." *The Bavarian Don Giovanni* is also a Leporello catalogue, but coming twenty years after this diary reference it appears to be a record of women Klee had known. Two of the names, Kathi and Cenzl, appear in Klee's journal accounts of his adventures as a student in Munich around the turn of the century. The name Mari might refer to "a ravishing little model" who posed in a life-study class when Klee was in Rome. The other two names are subjects for speculation—Aichele has suggested that they may refer to two popular contemporary sopranos, Emma Carelli and Thérèse Rothauser. In any case, the ludicrous bumpkin in Bavarian peasant costume is surely none other than Klee himself (we recall he had settled in Munich in 1906). His self-caricature climbs a ladder in the act of "windowing"—the verb *zu fenstern* meant, in Bavarian vernacular, to woo in this manner.

It is very curious that one should make such a list of names the subject of a painting. Indeed, I believe this example is unique in the realm of high art. Klee had started in 1919, the year after he ceased keeping a diary, to translate his private thoughts and emotions directly into graphic art. And he began in this picture an attempt to incorporate his private graphic musings into a more serious form of art, for the first time setting one of his whimsical, very personal cartoons to a composition of color units.

The color units in *The Bavarian Don Giovanni* are not the rectangles Klee had been using since 1916 in the *Lieder* pictures and which would serve him so well in his mature color compositions. Instead, they are the roughly triangular color elements of Delaunay's *Simultaneous Windows*. By using these color units to suggest draperies in the window frames—a backdrop for the act of windowing—Klee produced a characteristic visual pun.

A significant advance from this cartoonlike work is marked by *Hoffmannesque Scene* (1921, cat. no. 19). Here Klee introduced as a setting the flat color rectangles that were rapidly becoming a major part of his art. The dull brown and yellow rectangles are highly irregular in size and are not governed by the distorted grid structure that eventually became a foundation of Klee's color themes; but their taut flatness and closer correspondence to the rectangular picture format still make them a far more solid anchoring ground than the floating, Delaunay-like triangles of *The Bavarian Don Giovanni*. And because the rectangles are completely freed from all tasks of description and representation, they provide a more absolute setting for the action of the drawings. What has emerged is a new pictorial logic, one that would soon become central to Klee's thinking. In his prior attempts to find a place for his line within his paintings, Klee had relied on a more traditional approach in which linear contours served as the boundaries of color areas; color was partly defined by drawing and drawing partly defined by color. But in *Hoffmannesque Scene* the functions of color and drawing have been largely separated. By virtue of their clearer, more independent definition, they began to work together for Klee in a new, more successful way.

In some gemlike paintings executed between 1915 and 1919—for example, *The Idea of Firs* (1917, cat. no. 13)—Klee had used cubistic drawings with buckled surfaces to define the color areas. In them he made the drawings first and filled in the color afterward. But color became ever more dominant in Klee's thinking; he declared that he wanted to be a colorist "first and foremost." The continued subservience of color to line was increasingly unsatisfactory to him. Moreover, he very much wanted to preserve the uniquely personal character of his line, but he was discovering that line was not especially well suited to serve as a color boundary. In 1919 the independent color-rectangle composition emerged in his work as a means to defeat the confining role of natural contour and drawing and to liberate color. The operatic format of *Hoffmannesque Scene*,

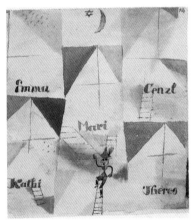

Paul Klee, *The Bavarian Don Giovanni*,
1919.
Watercolor and ink on paper,
22.5 x 21.3 cm.
Solomon R. Guggenheim Museum 48.1172x69
(cat. no. 15).

in which a drawing is superimposed on a color setting, marked an important advance in Klee's effort to incorporate drawing into painting. Although the drawing and color elements are related in this picture, like a text and a score, they maintain their independent identities. And as Klee's mastery of color grew, this technique enabled him to lend additional strength to his scratchy, idiosyncratic drawings.

Paul Klee, *Hoffmannesque Scene*, 1921. Color lithograph on paper, image 31.4 x 22.9 cm; sheet 35.5 x 26.1 cm. Solomon R. Guggenheim Museum 73.2029 (cat. no. 19).

Another significant aspect of *Hoffmannesque Scene* concerns its reference to the early nineteenth-century German poet and fabulist E. T. A. Hoffmann, who is best known today as the author of the story on which Tchaikovsky's *Nutcracker* ballet is based. Hoffmann was an important cultural figure in Germany by the turn of the century, and his work was much discussed at the Bauhaus in the early 1920s. His role as an authority on the fantastic, the grotesque, and the bizarre became very important to Klee, helping grant him sanction to explore those native interests within himself. Hoffmann showed him a way to transform his private fantasies and experiences into art. And more important, like Jacques Offenbach in his well-known opera *The Tales of Hoffmann*, Klee found Hoffmann's literary concepts to be a valuable basis for communicating private fantasies to a wider audience. The operatic paintings were, in fact, the first works that launched Klee into national, then international prominence. With their high charm and broad appeal, they became some of the artist's most popular and best-loved works. They allowed him not only to preserve the intimate, delicate character of his line, but also to continue to sustain within himself the child's spirit of fantasy and play.

That element of the childlike, so fundamental to Klee's art and so controversial, requires some explanation. When Klee decided to become a painter, he had felt compelled to circumscribe his sense of fantasy, to say "Farewell, elves, moon fairy, stardust. . . . Enough of magic!" His early encounter with the monuments of classical art in Italy had led him temporarily to abandon play in favor of "sober and small, unenthusiastic, rational procedures" in his medium. But when, later in his career, he was able to consult Mozart for aesthetic guidance, he found a different sort of classical model, one that did not demand his repentance of fantasy and permitted him, in good conscience, to integrate his reveries into his professional life. Sometime after 1916 or 1917, Klee's art began to display its characteristics of magic and fairy-tale enchantment—also hallmarks of Mozart in such works as *The Magic Flute*. For Klee reason was a basis for all creation but was not in itself the end of art. Truth asked of him that all things be present, so he readmitted magic and fantasy, to delight the child's heart in himself and to reach out to the child's heart in others.

One of the principal routes that Mozart found to universal synthesis was through the sensibility of children. Human development is most universal, most consistent crossculturally in its early stages, and something of that commonality remains with us even

in adulthood. Because Mozart, like many prodigies, had begun composing in childhood, he was aware of the special access that children can have to music. Furthermore, the eighteenth century was an age not only of enlightenment but also of rococo sensibility, in which childish delight became an acceptable subject for advanced art, as in the paintings of Jean-Honoré Fragonard and François Boucher. By developing viable ways to cultivate childlike playfulness and unsophisticated humor in their music, Mozart and other late-eighteenth-century composers were able both to fulfill an aesthetic ideal and to indulge simpler tastes and pleasant feelings. Their music embodies a special synthesis of earnestness and play, which is one reason for its appeal and accessibility, even to young listeners.

Thus, whimsy, fantasy, and playfulness were not merely personal indulgences for Klee; they also represented an aesthetic ideal. In his assessment of Mozart's achievement, Klee must have deduced that accessibility to children, which demands an understanding of and occasional borrowing from the young child's aesthetic, is a critical factor in attaining ultimate things in art. If young children are able to understand something about art, their understanding may be that much stronger when they are older. One of Klee's goals, then, was to transform serious visual art into something that, like late-eighteenth-century music, had more to do with the way young children naturally tend to paint and to think about art and picture-making—that is, into a system of expression oriented toward the early phases of human perception and learning development.

In 1914 Klee had written of the Modern movements:

> For these are primitive beginnings in art, such as one usually finds in ethnographic collections or at home in one's nursery. Do not laugh, reader! Children also have artistic ability and there is wisdom in their having it! The more helpless they are, the more instructive are the examples they furnish us; and they must be preserved free of corruption from an early age. . . . All this is to be taken very seriously, more seriously than all the public galleries, when it comes to reforming today's art.

He had been led to these conclusions largely by pervasive talk of "primitivism" among contemporary painters and critics; by the borrowings in the work of the Parisian avant-garde from African and other ethnographic sources; and by careful observation of his own son's artistic development. And so Klee set out to win acceptance of the childlike in serious painting, as Mozart had done in music. A century earlier the German painter Philipp Otto Runge had concerned himself with the artistic development of children. The Impressionists had spoken of the "innocent eye." Emile Bernard, Gauguin, and van Gogh spoke of "painting as children paint." But Klee was the first to paint pictures that children can understand in terms of what they already

know about art. That is because one of Klee's means of reforming art was to introduce the actual methods and techniques of the child artist: heavy outlining, savage scribbling, scratching, smearing, spotting, staining, blotting, and so on, some of which later became part of the standard vocabulary of painting.

The messy, smudged, and blotted lines we see in *Hoffmannesque Scene* became an integral component of Klee's operatic formats and of his drawing in general during the 1920s. *Hoffmannesque Scene* is a lithograph, but in an effort to duplicate this misty, almost atmospheric texture, and so to adapt his linear art more idiomatically into painting, Klee invented, around 1920, the technique of oil transfer drawing, many examples of which are included in this catalogue. The oil transfer drawing was executed by brushing thinned oil paint onto one side of a piece of paper, then transferring the ink to another paper by drawing with a stylus on the back of the painted sheet. The paint could then be pressed onto the final support, which was often a damp ground of watercolor. The technique was a means to give body to and expand his inherently flat, etchinglike drawings; to integrate them into his rich, subtle color settings; and to give them some of the fresh, spontaneous, childlike character he so valued. Klee also practiced the technique of drawing in pen and ink directly on still-moist watercolor. This technique imparted to some of the lines the blurred, misty textures of the oil transfer. Both methods realized for Klee a goal he had been seeking for at least fifteen years, "the style that connects drawing and the realm of color," a "saving transfer of my fundamental graphic talent into the domain of painting."

During the fourteen years when Klee was producing his operatic paintings, he also created many works that, although they do not conform strictly to the definition—narrow-line drawing directly superimposed on an absolute color composition—can yet be viewed in close relationship to them, because of the special ways in which they unite his etchinglike line with color. One distinguished example is the marvelous, almost magical *Red Balloon* (1922, cat. no. 27). Here Klee conjures the most delicate color sensibility in floating areas of rectangle composition; the effect is to defeat the sense of pictorial gravity, to create a pictorial antigravity, which lifts the balloon form aloft and causes its gondola to swing gently. Such works demonstrate that Klee's operatic concept was helping imbue even his free linear improvisations and storybook drawings with a new strength.

Operatic-style color-rectangle compositions also provided an effective setting for another group of works, the script pictures, such as we see in *Curtain* (1924, cat. no. 33). Klee's drawings usually began with a kind of spontaneous doodling. In some instances he would encourage these free-form doodles into images relevant to feelings or thoughts of the moment. In many other works, such as *Curtain*, he would use the doodle as the basis for a constructive drawing, in which he would build a complex

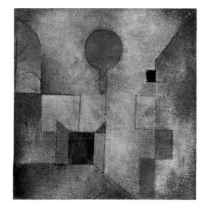

Paul Klee, *Red Balloon*, 1922.
Oil (and oil transfer drawing?) on chalk-primed gauze, mounted on board,
31.7 x 31.1 cm.
Solomon R. Guggenheim Museum 48.1172x524
(cat. no. 27).

image by methodically adding unit to unit—*x*'s, *o*'s, dashes, and so forth. The result was a carefully created, dynamically balanced structure that nonetheless managed to express his playful, spontaneous wit. These script notations must have originated in Klee's acute sensitivity, as both a pictorial artist and a musician, to the very special beauty of musical calligraphy. The sign-construction system also gave him a method to temper and discipline his free style of drawing. But above all, he wanted to appropriate for his own art some of the delight he found in the graphics of musical composition.

Notwithstanding Klee's many and varied successes with the flat color-rectangle format, it should be understood that he viewed the flat color theme at least partly as a means to a higher end. For Klee's ultimate goal and ambition lay in his desire to realize in painting what he called "higher polyphony"; that is, something comparable to the great, polyphonic instrumental compositions of the late eighteenth century, the symphonies and concerti of Mozart, Haydn, and Beethoven. And he believed that to do this he needed to devise a successful system of pictorial polyphony.

To his students at the Bauhaus Klee offered the following pronouncement on this crucial subject:

> There is polyphony in music. In itself the attempt to transpose it into art would offer no special interest. But to gather insights into music through the special character of polyphonic works, to penetrate deep into this cosmic sphere, to issue forth a transformed beholder of art, and then to lurk in waiting for these things in the picture, that is something more. For the simultaneity of several independent themes is something that is possible not only in music; typical things in general do not belong just in one place, but have their roots and organic anchor everywhere and anywhere.

Klee defined polyphony in its most general sense as "the simultaneity of independent themes." Thus, in the great examples of late-eighteenth-century musical polyphony, we hear two or more melodies or themes going on at the same time and interacting to form a whole greater than the sum of their individual melodic contents. Having satisfactorily defined a type of color theme in the flat rectangle format, Klee sought to develop a system that would enable him to combine individual color themes simultaneously within a single composition.

Klee further envisioned pictorial polyphony as a rational, teachable, quantifiable system for constructing a Modern type of pictorial space using transparent, overlapping color rectangles to replace the outmoded system of Renaissance linear perspective. It was also a method of spatial construction that conformed to the rationalistic, geometric, Constructivist thinking that prevailed among his colleagues at the Bauhaus.

1929

kurs paula klee — unterricht paul klee
pětihlasá polyfonie — fünfstimmige polyphonie

Klee declared that "polyphonic painting is superior to music in that, here, the time element becomes a spatial element." Throughout the 1920s, during his tenure at the Bauhaus, Klee directed his foremost energies and attention to working out problems of pictorial polyphony, and they were very much emphasized in his classroom lectures. Countless illustrations of his polyphonic theories appear in his class-lecture notes. In fact, so central to his thinking and pedagogy did this concept become that an example of five-part polyphony appears as the sole illustration next to Klee's course offerings in the Bauhaus course catalogue of 1929.

It would be difficult to overemphasize the importance of the concept of polyphony in Klee's thinking about art. For him the idea of the simultaneity of independent themes was a key not only to all higher aesthetics, but also to all organic life and to the structure of the universe. He often spoke of the polyphony of nature's forms and actions, referring to the ways in which complex physical structures and processes interact simultaneously in nature to create organic wholes far greater than the sum of their parts. This was one reason for his ceaseless fascination with plant and microbe forms, botany and biology, and for the biomorphic forms that often appear in his work, as in the polyphonic watercolor *Loose Coil* (1932, cat. no. 61). His concept of higher polyphony was based in part on this idea of bringing complex structures to a higher plane of existence, in the way that nature is additive, cumulative, and complex. Although higher polyphony referred principally to the musical achievements of the late eighteenth century, and above all to those of Mozart, it also signified to Klee a kind of utopian, ultimate synthesis in art.

Between 1920 and 1932 Klee worked with a great variety of pictorial formats and pedagogical illustrations that he considered polyphonic in one sense or another. The

operatic formats were one such instance; in these works the ground themes of color are perceived and interact simultaneously with the linear themes superimposed upon them, and consequently both are enriched. Klee regarded the complex polyphony of opera—its combinations of music, text, costume, staging, and lighting—with great affection. He also considered certain of his drawing methods contrapuntal and polyphonic, in instances when lines mirrored one another or formed overlapping, interpenetrating structures. We find these methods in *Verging on Despair, Portrait* (1927, cat. no. 47) and in *In Angel's Keeping* (cat. no. 54), *In Readiness* (cat. no. 55), *Lying As Snow* (cat. no. 56), and *The Clown Emigrates* (cat. no. 57), all 1931. The highly improvisatory, contrapuntal type of drawing is found in Klee's work from about 1915. It was originally inspired by his friendship with and exposure to the work of Kandinsky, and became integrated with his own impulse to doodle and improvise with line. Although Klee's polyphonic formats tend to emphasize the constructive and the rational, the animated forms of these drawings conspicuously display his whimsical and playful side.

But the most prominent and important of Klee's polyphonic formats was the one that employed overlapping, transparent color planes to create pictorial depth and to modulate the interactions of color. This was, between 1920 and 1932, the principal method by which he attempted to achieve a simultaneous interaction and perception of color themes in a single painting. The watercolor *Two Ways* (1932, cat. no. 64) is one of many examples of this technique. The title of the painting derives from one of Klee's oracles to his students at the Prussian Art Academy in Düsseldorf, where he taught in 1931–32 after leaving the Bauhaus. He declared, "That is the way of polyphony, where the two independent ways come together." In the watercolor this notion is reinforced by the two small arrows that thrust toward one another from opposite sides of the composition.

It should be noted that Klee's overlapping-plane technique involves two technical variations: actual transparent overlays and depicted transparent overlays. We see the two techniques combined in *Hat, Lady, and Little Table* (1932, cat. no. 60). To create actual transparent overlays, Klee would lay a thinned-paint wash directly on top of another paint layer and so create a new, third color. In depicted transparency, where planes intersect and appear to overlap, Klee indicated the zone of intersection with a completely new color. The two methods are at times almost indistinguishable in their ability to create pictorial depth.

The overlapping-color-plane methods enabled Klee to create many outstanding works. But by 1931 he had conceived of a superior solution to the problem of color polyphony. As we see in *Barbarian Sacrifice* (1932, cat. no. 58), he invented a new type of flat color theme, in which he used tiny dots of color to lay carefully organized, transparent screens across entire pictures. This proved to be a momentous innovation

because it soon enabled Klee, for the first time, to develop two fully separate color-themes in the same picture, one in the background and one in the foreground. The result is a simultaneous interaction of truly independent themes. Although Klee's color dots intensify pictorial light, as in Pointillism, their primary purposes are to create depth and to carry a separate color voice. In a letter Klee once referred to this technique as "'so-called pointillism,' but because of its polyphonic function I like to think of it as 'counter-pointillism.'"

In *Polyphony*, also of 1932, the artist provided a clear demonstration of how this system works. In the background he composed a color-rectangle theme. On top of this he set another color theme, composed of the screen of dots. There exist two fully independent themes, yet we perceive the picture as a fluid, coloristic, atmospheric unity. As in late-eighteenth-century musical polyphony, what impresses us most is the feeling of wholeness, the overall tonal organization, which brings the separate identities of individual melodies together in a coherent, single identity. And notwithstanding the coloristic fluidity and depth of the painting, it remains extremely easy to analyze its component elements of point, line, plane, and color, as Klee demanded of any perfect work of art.

In *Ad Parnassum*, of the same year, Klee created his climactic work of pictorial polyphony. *Ad Parnassum* is his greatest single work of art. It is his second-largest painting, the largest prior to 1937, and it is by far the most complex and ambitious painting of his career. For the most part, Klee's oeuvre is made up of very small pictures executed in semi-improvisatory techniques, derived from what he termed his "original realm of psychic improvisation" and based in his almost limitlessly fertile gift of linear invention. But *Ad Parnassum* is carefully planned and painstakingly executed, a fluid harmony ruled by a bold and powerful conception. In no other single painting did Klee invest so much. This exceptional investment becomes understandable once we realize that Klee intended *Ad Parnassum* to be his ultimate polyphonic work, the summary and culmination of long years of dedicated explorations.

The title *Ad Parnassum* refers to the linear mountain form in the painting, which might be taken to suggest Mount Parnassus in the Peloponnesian Islands. According to ancient Greek mythology, Mount Parnassus was the home of the god Apollo and the muses of the fine arts. But more significant, the title alludes to a famous eighteenth-century treatise on polyphony and counterpoint, *Gradus ad Parnassum* (*The Stairway to Parnassus*). This book greatly influenced Mozart, Haydn, and Beethoven in their formative years and guided their understanding of polyphonic theory. Klee borrowed from its title because *Ad Parnassum* is his own codification of pictorial counterpoint and polyphony.

As in *Polyphony*, Klee began *Ad Parnassum* by composing a color-rectangle theme in

Paul Klee, *Polyphony*, 1932.
Tempera on canvas, 66.5 x 106 cm.
Öffentliche Kunstsammlung Basel,
Emanuel Hoffmann Stiftung.

the background. Here he conceived a gentle yet insistent theme in blue composed of motifs of gray; earthy browns and greens; pale, very yellow greens; and several hues of blue. In this color theme, the first of two, Klee successfully realized the ideal he had once described to his students as the "dynamic expression" of a "rhythmic arrangement of squares organized according to their color types," resulting in a "highly dynamic individuality of colors, based on a tonal-dynamic structural rhythm."

Next Klee introduced the linear elements. However, the drawing in *Ad Parnassum* is not the nervous, delicate, improvisatory drawing of his earlier work; it is, rather, a precursor of the bold, heavier, brush-drawn line that came to dominate his late style, from 1937 to his death in 1940. With this new type of line Klee set down the mountain and the gateway forms, the two voices that create the striking signature of *Ad Parnassum*. By employing simple, forceful shapes, such as are often found in melodic lines in music, Klee provided an image that is monumental but not ponderous, one that is as readily recognizable, memorable, and easily describable as the epic motifs that often characterize famous works of music.

As the last stage in composing *Ad Parnassum*, Klee set down the staccato rhythms of the second color theme in the screen of dots. But he did not lay on the dot colors directly, as he had in *Polyphony* and *Barbarian Sacrifice*. He used instead a technique he had devised earlier in 1932 that combines counter-pointillism with glazing. Over the entire painting he laid a screen of plain white dots. Then over each white dot he applied a wash or series of washes of the colors he wanted in each passage. This method gave Klee an extremely precise means of control in the orchestration of colors. With it he was able masterfully to create a vibrant harmony of blues, counterpointed by areas of very hot reds and oranges. It is a perfect synthesis of local and atmospheric

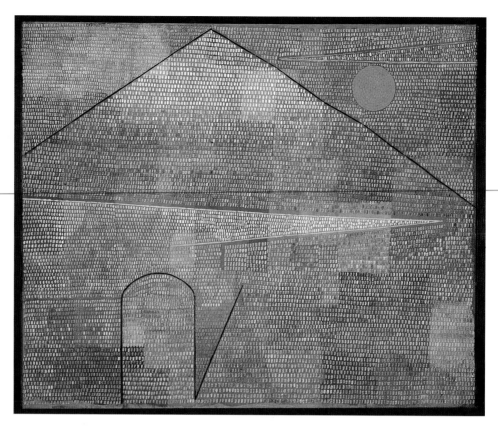

color, as alive as the hazy-cool-blue harmony of a Peloponnesian landscape at sundown. Over the course of three decades, Klee had with methodical determination cultivated a remarkable color sensibility, a singular ability to choose tones and hues and to order them into sensitive transitions and vital thematic arrangements. Here these talents enabled him to realize the great moral strength of color, the antidecorative depth and power of color, of which he had dreamed as a young man in the Roman Campagna.

As we have seen, in *Ad Parnassum* Klee recapitulated his years of exploration and experiment in color composition. He also incorporated into the painting the principal iconographic elements of his oeuvre up to 1932—color rectangles, counter-pointillism, and arrow vectors (in the cloudlike, thrusting forms at the center and upper right), and even natural forms that hark back to his boyhood depictions of his native Bern and its surroundings. Out of these elements he forged a definitive polyphonic painting, one of independent formal life and rich associative possibilities. In sum, *Ad Parnassum* is a comprehensive work, the only comprehensive work of Klee's career.

It is not altogether surprising that Klee should have undertaken a major, summational project late in 1932. There can be little doubt that by then he had foreseen the end of his teaching career and a dramatic change impending in his life. For years he had felt anxious about the rising power of the Nazis, and by late 1932 the political situation in Germany had become very tense. The next year the Nazis indeed came to power. In effecting the new policy of "restoring the indigenous character of German

art instruction," the academy in Düsseldorf dismissed Klee from his professorship. Some years later his art was branded as "degenerate" and was banished from German public collections. After being, in effect, hounded out of Germany, Klee was obliged in 1933 to seek refuge in Switzerland, where, although a native, he was not a citizen. (His application for Swiss citizenship was not approved in his lifetime.) He was, in a sense, a man without a country. Thus, the years from 1933 to 1936 formed a period of great professional and personal hardships. Formerly so prolific and inventive, Klee now found it difficult to maintain his creative impetus. His output declined as he groped unsuccessfully for new directions, and he felt compelled at times to return for sustenance to earlier ideas.

The end of Klee's teaching career marked the end of his dedication to the programmatic exploration of color. In the remaining years of his life he reverted increasingly to what he called his "fundamental graphic talent," as he cultivated the heavy, painterly lines of his late style. In *Ad Parnassum* Klee had marked this turning point; he forged a new synthesis between the realm of color and the realm of drawing and thereby reunited the principal currents of his art. In the process he created a quiet manifesto, a final statement of the values that had stimulated his highest ambitions and his dreams of a noble art of color.

The powerful brush-drawn line that makes its debut in *Ad Parnassum*, along with a marked readjustment in the relationship between line and color, heralds an impending major transformation in Klee's art. It signaled an authentic and substantial strengthening of his line, the first real advance in two decades. The heavy, brush-drawn line now existed as a potential new force. To realize that potential, Klee needed to invent new formats and applications. To the extent that he was able to ponder artistic problems during the difficult years 1933–36, what must have most concerned him was how to formulate a new type of linear art to assume the place that color had formerly occupied in his ambitions.

But Klee's biggest problem during those years was that he was scarcely able to marshal any ambition at all. In 1934 his output dropped to 219 works, still a large number but more than 250 fewer than in the previous year. In 1935 his difficulties were immeasurably compounded by the discovery that he had contracted scleroderma, a progressive, inflammatory tissue disease, which ultimately caused his death five years later. During this year Klee's production again dropped sharply, to 148 works, and among these, genuinely good pictures were rare. In 1936 the once extraordinarily prolific Klee almost ceased artistic activity altogether; only twenty-five works in all mediums appeared that year, and these were mostly of a retrospective nature, such as *New Harmony*. Klee seems to have been close to giving up.

Of all his feats of perseverance, none is quite as remarkable as the turnabout in his

career that occurred in 1937. Recovering from physical debility, discouragement, and multiple life crises, he abruptly reversed the three-year decline that had left him at a virtual standstill. In 1937 he increased his production to 264 works, in 1938 to 489 works—more than in 1933. Then in 1939, the last full year of his life, Klee created the staggering total of 1,253 pictures. Of course, quantity is not the measure of artistic triumph. What truly warrants our admiration is that, in the face of impending death, Klee confronted and resolved significant artistic challenges. He mapped out new artistic territory, and it was territory of consequence. He forged a powerful style, and in doing so conquered resoundingly the problem that had stymied his artistic beginnings thirty-five years earlier; namely, his innate graphic sensibility and its tendency toward fragility, grotesquerie, and illustration. In his three final years, Klee seized and cultivated a wholly new approach to drawing—an authentically *painterly* approach—one that completely transformed the sensibility of his line.

We have seen how Klee searched for ways to integrate his wiry, etchinglike line into his painting and thereby elevate the character of that line. In his late style the line itself became painterly, by virtue of its flat, thickly brushed quality. There was no longer any conflict to reconcile. Klee began to draw with the brush or crayon in bold, rough, open strokes, as we see in *Rolling Landscape* (1938, cat. no. 72), instead of with scratchy pen lines or oil transfer. Though his drawing remained essentially improvisatory and gestural, the new big, flat, vigorous line enabled him for the first time to use his drawing as a means to lay out and structure his paintings. Line was no longer merely a guest in a color field or a superimposition on a precomposed color theme. Line could now dictate the order, structure, and modulation of colors. Although color and line retain independent identities, color is now accommodated to line, rather than vice versa. Indeed, in the late work, a line nearly always demands a color variation in its immediate vicinity. Often an unpainted or white aureole surrounds each of these lines, commanding respect for them and reinforcing their dominant position.

Line rules unequivocally in most of Klee's late approaches, such as the "light bar style" of 1937 (in, for example, *Fruitfulness*, cat. no. 68, and *Peach Harvest*, cat. no. 69) and the heavy, dark bars that create jigsawlike compositions (as in *Rolling Landscape*). In many pictures, among them *Boy with Toys* (1940, cat. no. 77), Klee made explicit the debt of this line to children's art through the simple, childlike rendering of the subject. Like the drawings of the very young, these treatments are flat; they neither create depth nor suggest volume. The visualization is direct and economical. Again, such borrowings are a source of some of the appeal and universality of Klee's art, and they enabled him to exploit the raw energy of the child artist.

It seems almost miraculous that in three years of acute physical decline Klee could manage to endow his drawing with a radical new strength, and thereby to resolve so

decisively a problem that had confronted him throughout his career. From the broad, rough line of children's art he forged an artistic tool of genuine force—a line of stability, assertion, and power—that was one of the most daring and important innovations in painting of 1935–45. It endowed his drawing and painting with a monumentality they had never known before and with a new level of content, and it formed one of the most valuable features of his rich legacy to later generations of artists.

1. Felix Klee, ed., *The Diaries of Paul Klee, 1898–1918*, translated by Max Knight, Pierre B. Schneider, and R. Y. Zachary (Berkeley and Los Angeles: University of California Press, 1964). This is the source I have used for all quotations from the artist.

2. K. Porter Aichele, "Paul Klee's Operatic Themes and Variations," *Art Bulletin* 68, no. 3 (Sept. 1986), pp. 450–66.

CATALOGUE

1. *Gemmi Pass, Valais Alps* (*Gemmi Passhöhe, Walliseralpen*), ca. 1895

Pencil on paper

9.9 x 16.8 cm

Solomon R. Guggenheim Museum 48.1172x536

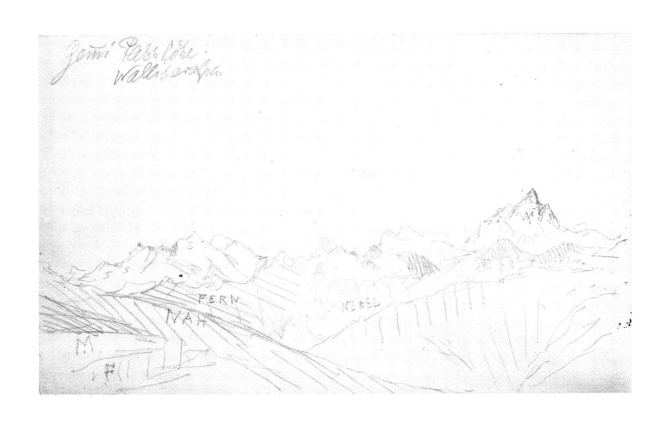

2. *Hilterfingen*, July 19, 1895

Ink on paper

9.5 x 16.9 cm

√.101 — 19.VII.95

3. *Thunersee near Schadau* (*Thunersee bei Schadau*), September 8, 1895

Ink on paper

9.9 x 16.8 cm

Solomon R. Guggenheim Museum 48.1172x537

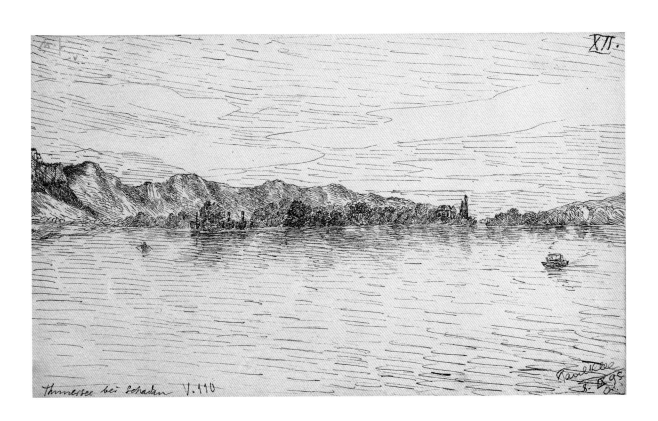

Thunersee bei Schadau V.110

4. *Two Gentlemen Bowing to One Another, Each Supposing the Other to Be in a Higher Position (Invention 6)*
(*Zwei Männer, einander in höherer Stellung vermutend, begegnen sich {Invention 6}*), September 1903
Etching on paper
Plate and sheet 11.8 x 20.7 cm
Solomon R. Guggenheim Museum 48.1172x365.1

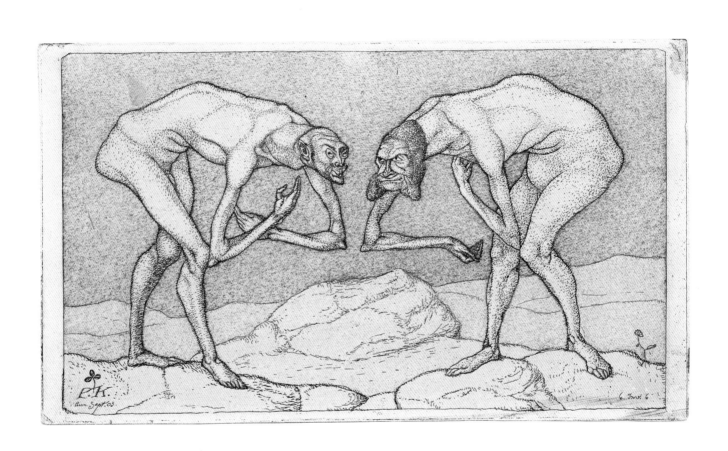

5. *Virgin in a Tree (Invention 3)* (*Jungfrau {Träumend} {Invention 3}*), July 1903
Etching on paper
Plate 23.8 x 29.9 cm; sheet 31.8 x 42.4 cm
Solomon R. Guggenheim Museum 48.1172x365.2

6. *Comedian (Invention 4) (Komiker (Invention 4)),* March 1904
Etching on paper
Plate 15 x 16.2 cm; sheet 15.9 x 17.2 cm
Solomon R. Guggenheim Museum 48.1172x365.3

Komiker. (Inv. 4.)

7. *Perseus (Wit Has Triumphed over Sadness) (Invention 8)*
(Perseus {Der Witz hat über das Leid gesiegt} {Invention 8}), December 1904
Etching on paper
Plate 12.8 x 14.3 cm; sheet 27.9 x 31.8 cm
Solomon R. Guggenheim Museum 73.2040

*. Proseus (der Witz hat über das Leid gesiegt.) *

FK Bern 1904
* Jm 8

8. *Aged Phoenix (Invention 9) (Greiser Phönix {Invention 9})*, 1905

Etching on paper

Plate 27.1 x 19.8 cm; sheet 34 x 24.8 cm

Solomon R. Guggenheim Museum 75.2203

9. *Flower Bed (Blumenbeet)*, 1913
Oil on cardboard
28.2 x 33.7 cm
Solomon R. Guggenheim Museum 48.1172x109

10. *Garden of Passion* (*Garten der Leidenschaft*), 1913
Etching on paper
Plate 9.2 x 14 cm; sheet 23.2 x 29.8 cm
Solomon R. Guggenheim Museum 48.1172x365.7

11. *Acrobats (Akrobaten)*, 1914

Ink on paper, mounted on cardboard
Paper 20.9 x 15.1 cm; cardboard 22.7 x 16.7 cm
Solomon R. Guggenheim Museum, Gift, Katharine Kuh 81.2908

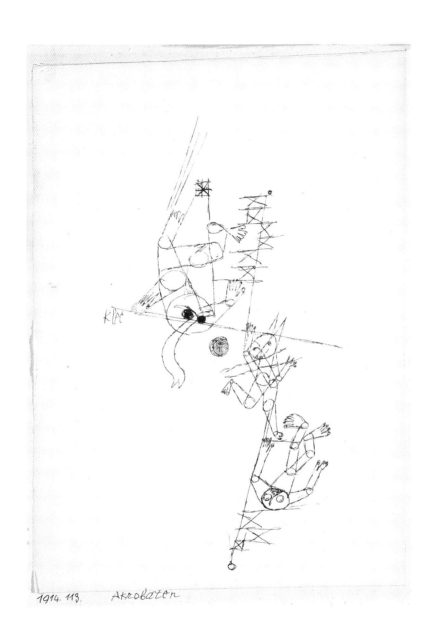

1914. 113. Akrobaten

12. *Little Cosmos (Kleinwelt)*, 1914

Etching on paper

Plate 14.4 x 9.6 cm; sheet 41.9 x 32.1 cm

Kleinwelt Klee

13. *The Idea of Firs (Die Idee der Tannen)*, 1917
Watercolor and pencil on paper, mounted on cardboard
Paper 24 x 16 cm; cardboard 31.4 x 23.4 cm
Solomon R. Guggenheim Museum, Bequest under the will of Eve Clendenin 74.2101

Klee

1917. 49.

14. *Jumping Jack (Hampelmann)*, 1919

Pencil, oil transfer drawing, and watercolor on paper, mounted on cardboard

28.4 x 22 cm

Solomon R. Guggenheim Museum, Thannhauser Collection, Bequest of Hilde Thannhauser 91.3908

1919. 214.

15. *The Bavarian Don Giovanni (Der bayrische Don Giovanni)*, 1919

Watercolor and ink on paper

22.5 x 21.3 cm

Solomon R. Guggenheim Museum 48.1172x69

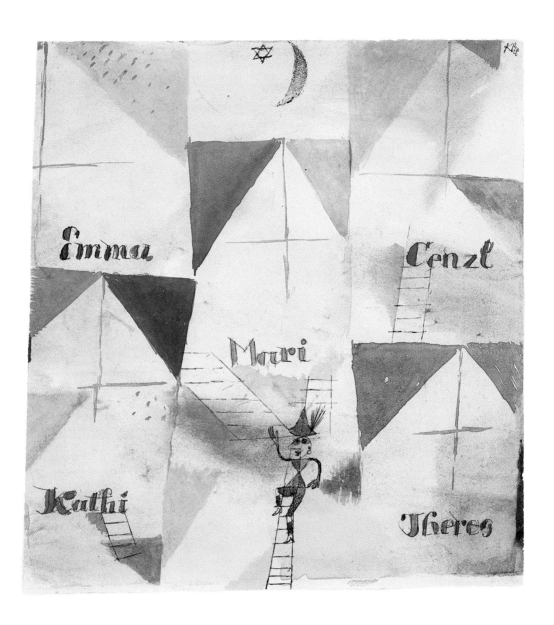

16. *Before the Festivity (Vor dem Fest)*, 1920

Watercolor and oil transfer drawing on paper, mounted on cardboard

Paper 31.1 x 23.7 cm; cardboard 37.6 x 32.8 cm

Solomon R. Guggenheim Museum 48.1172x68

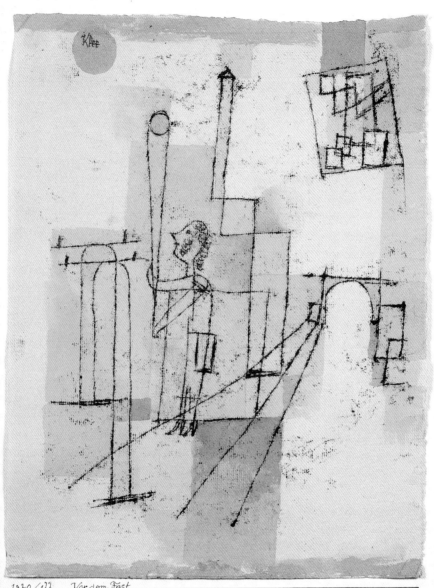

Klee

1920/177 Vor dem Fest

17. *White Blossom in Garden* (*Weisse Blüte im Garten*), 1920
Oil on paper, mounted on paper
Paper support 17.8 x 17.2 cm; paper mount 22 x 20.7 cm
Solomon R. Guggenheim Museum 48.1172x157

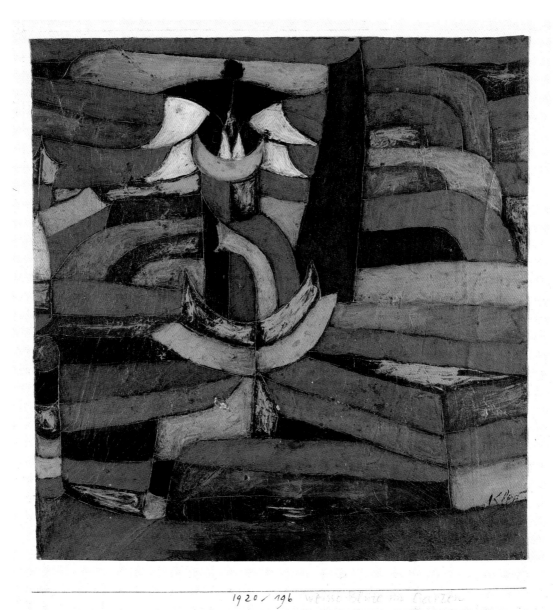

1920/196 Weisse Blüte im Garten

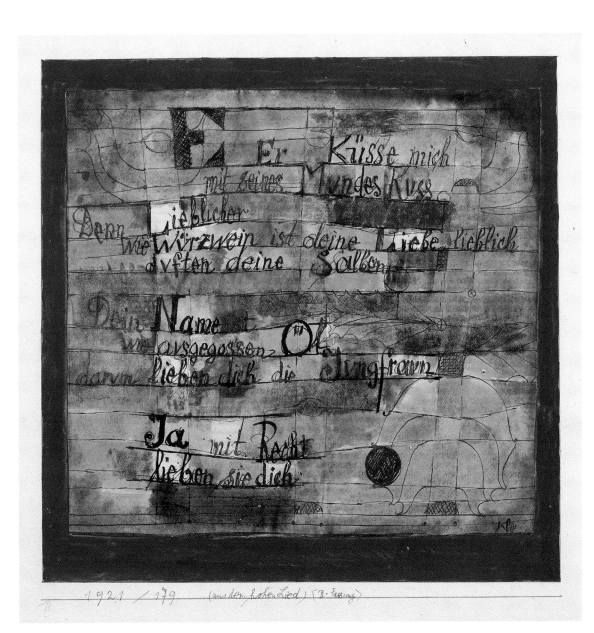

Er Küsse mich
mit seines Mundes Kuss
Denn Lieblicher
wie Würzwein ist deine Liebe lieblich
duften deine Salben.

Dein Name ist
wie ausgegossen Öl,
darum lieben dich die Jungfrawn.

Ja mit Recht
lieben sie dich.

1921 / 179 (aus dem hohen Lied) (II. Fassung)

19. *Hoffmannesque Scene (Hoffmanneske Szene)*, 1921
Color lithograph on paper
Image 31.4 x 22.9 cm; sheet 35.5 x 26.1 cm
Solomon R. Guggenheim Museum 73.2029

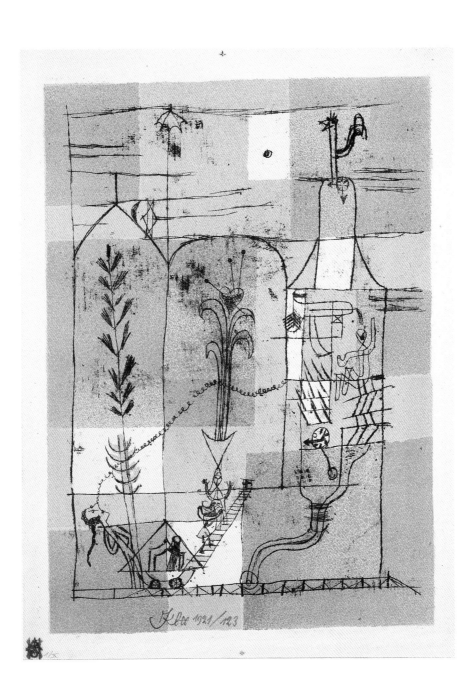

Klee 1921/123

20. *Night Feast (Nächtliches Fest)*, 1921

Oil on paper, mounted on cardboard, mounted on board painted with oil
Paper 36.9 x 49.8 cm; board 50 x 60 cm
Solomon R. Guggenheim Museum 73.2054

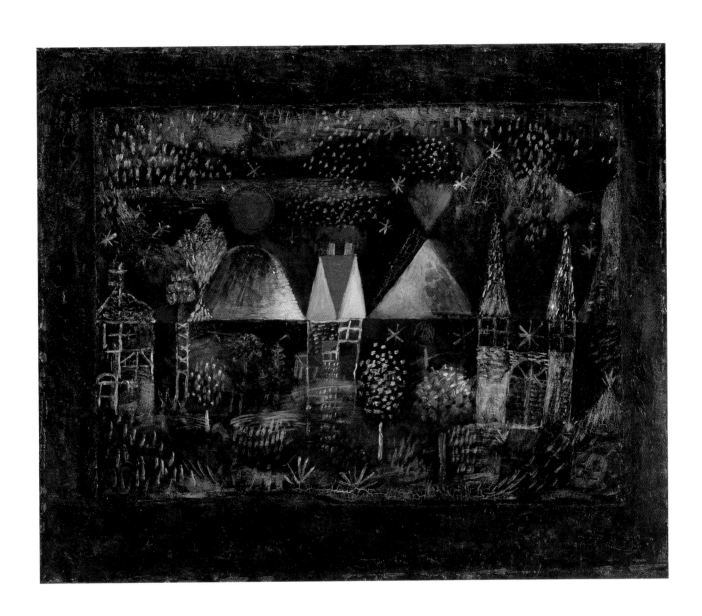

21. *Runner at the Goal (Läufer am Ziel)*, 1921

Watercolor and pencil on paper, bordered with watercolor on the cardboard mount
Paper 30.7 x 22.7 cm; paper and border 32.5 x 23.6 cm; cardboard 39.3 x 30.2 cm

Solomon R. Guggenheim Museum 48.1172x55

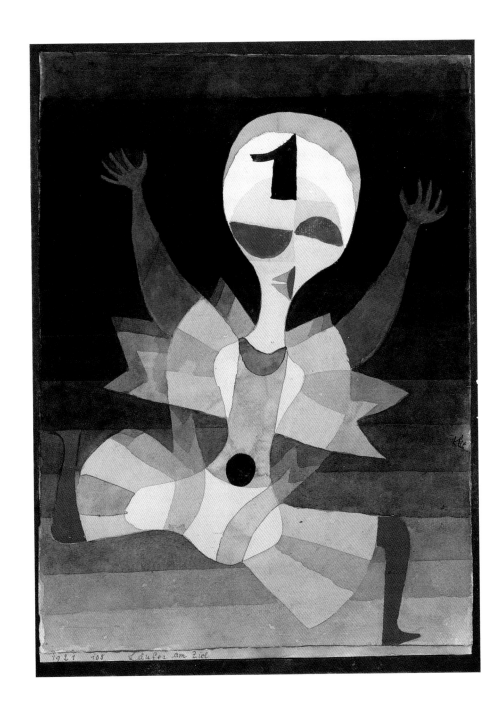

1927 105 Läufer am Ziel Klee

22. *Aging Venus (Alternde Venus)*, 1922

Watercolor and oil transfer drawing on paper, bordered with watercolor on the board mount

Paper 29.6 x 58.5 cm; paper and border 32.1 x 58.5 cm; board 32.8 x 58.8 cm

Solomon R. Guggenheim Museum 48.1172x63

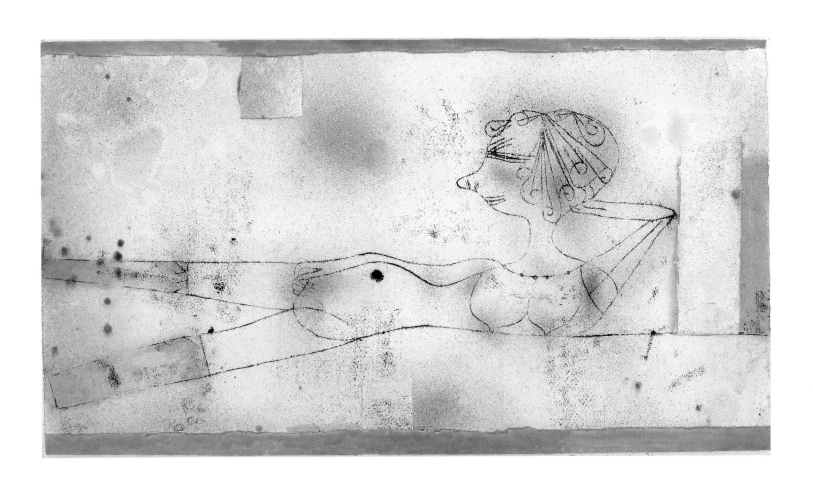

23. *Contact of Two Musicians (Kontakt zweier Musiker)*, 1922
Watercolor and oil transfer drawing on chalk-primed linen gauze,
mounted on paper partially painted around the gauze
Gauze approximately 45.4 x 29.2 cm; paper 64.2 x 47.9 cm
Solomon R. Guggenheim Museum 48.1172x527

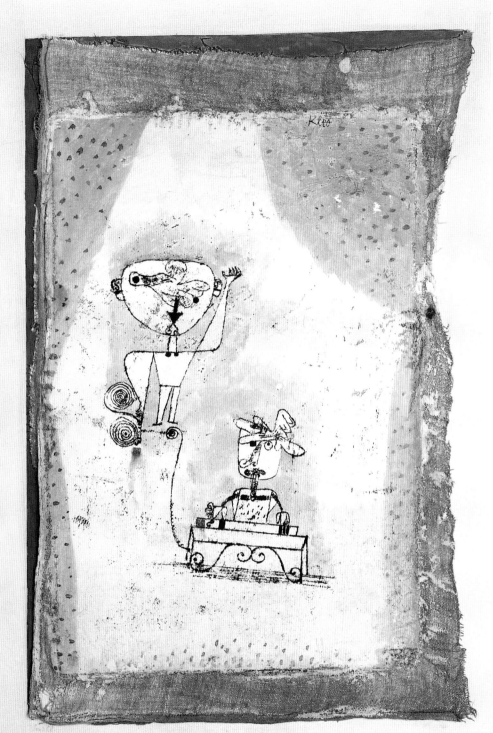

1922 /93 Konzert zweier Musiker

24 *Costumed Puppets (Kostümierte Puppen)*, 1922

Ink on paper, mounted on cardboard
Paper 24.2 x 17.3 cm; cardboard 31.9 x 25 cm

1922/85 Kostümierte Puppen

25. *Dance You Monster to My Soft Song!* (*Tanze Du Ungeheuer zu meinem sanften Lied*), 1922

Watercolor and oil transfer drawing on plaster-primed gauze, bordered with watercolor on the paper mount

Gauze approximately 35.2 x 29.2 cm; gauze and border 40 x 29.2 cm; paper 44.9 x 32.6 cm

Solomon R. Guggenheim Museum, Gift, Solomon R. Guggenheim 38.508

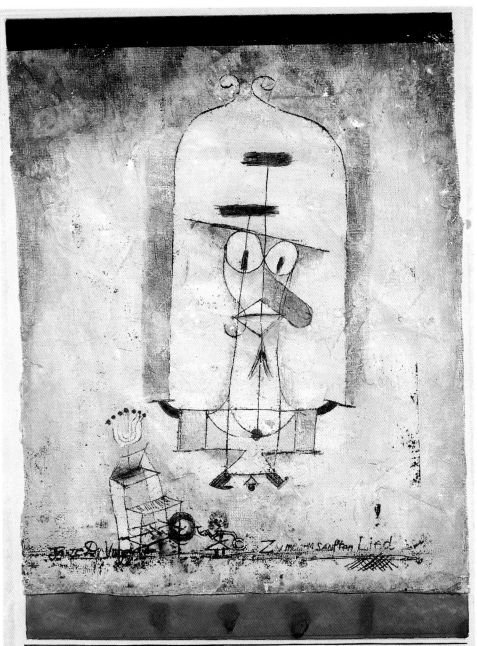

1922/54 Tanze Du Ungeheuer zu meinem sanften Lied!

26. *Fright of a Girl* (*Schreck eines Mädchens*), 1922

Watercolor, india ink, and oil transfer drawing on paper, bordered with india ink on the paper mount
Paper support 29.7 x 22 cm; paper support and border 31.1 x 22 cm; paper mount 32.7 x 23 cm

27 *Red Balloon (Roter Ballon)*, 1922

Oil (and oil transfer drawing?) on chalk-primed gauze, mounted on board

31.7 x 31.1 cm

Solomon R. Guggenheim Museum 48.1172x524

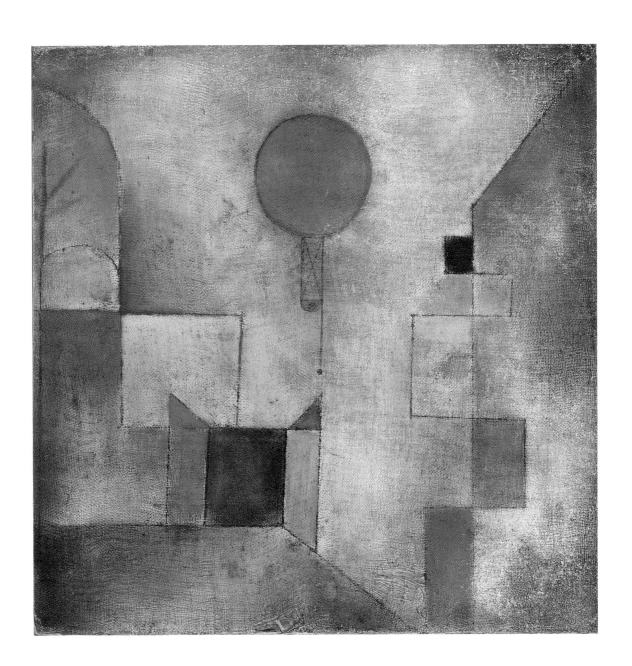

28. *Dwarf Herald on Horse (Zwergherold zu Pferd)*, 1923

Oil with varnish and gold leaf on paper, bordered with watercolor on the cardboard mount
Paper 23.3 x 17.5 cm; paper and border 25.7 x 19 cm; cardboard 30.8 x 23 cm

Solomon R. Guggenheim Museum 48.1172x525

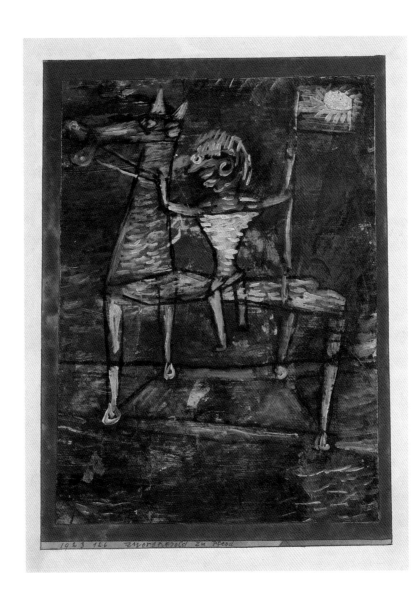

29 *Singer of Comic Opera (Sängerin der komischen Oper)*, 1923

Watercolor and ink on paper, mounted on cardboard
Paper 29.2 x 23.5 cm; cardboard 37.7 x 30.4 cm

Solomon R. Guggenheim Museum 48.1172x61

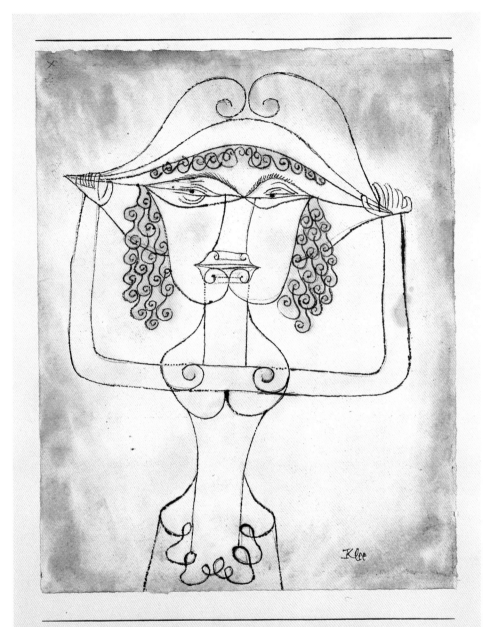

1923. 118. Sängerin der komischen Oper.

30. *Tightrope Walker (Seiltanzer)*, 1923

Color lithograph on paper

Image 43.5 x 26.8 cm; sheet 52.1 x 38.1 cm

Solomon R. Guggenheim Museum 57.1474

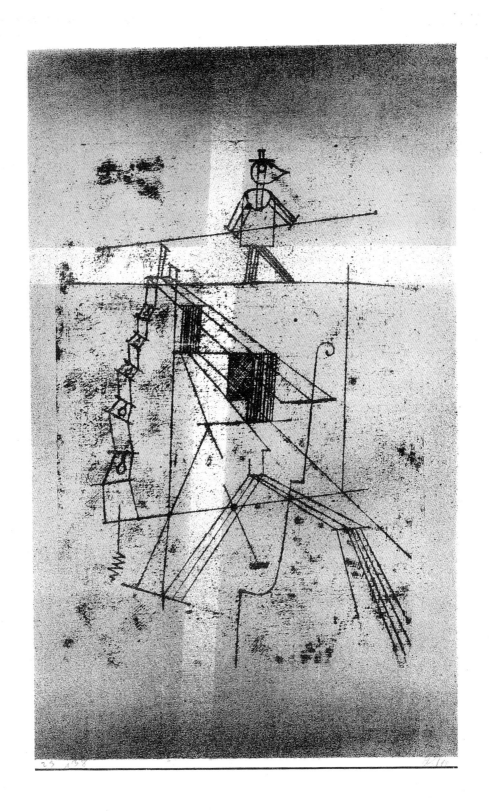

31. *Tropical Gardening (Tropische Garten Kultur)*, 1923

Watercolor and oil transfer drawing on paper, bordered with watercolor on the cardboard mount
Paper 17.9 x 45.5 cm; paper and border 19.9 x 48.9 cm; cardboard 24.5 x 56.5 cm
Solomon R. Guggenheim Museum, Gift, Solomon R. Guggenheim 37.509

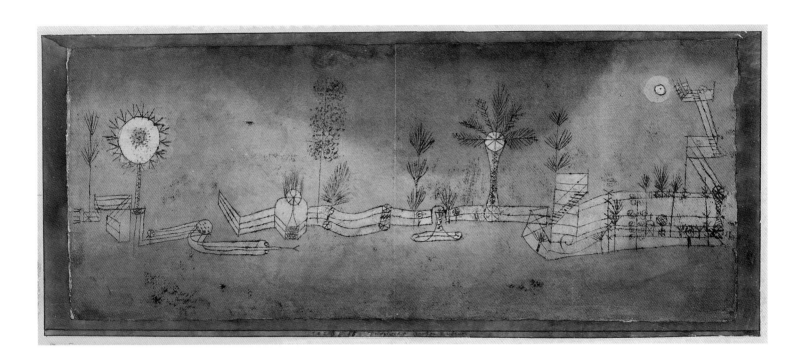

32. *A Sketch for a Portrait of a Costumed Lady* (*Bildnis Skizze einer kostümierten Dame*), 1924
Ink on paper, mounted on cardboard
Paper 23.2 x 14.6 cm; cardboard 32.4 x 25.1 cm
Solomon R. Guggenheim Museum 48.1172x124

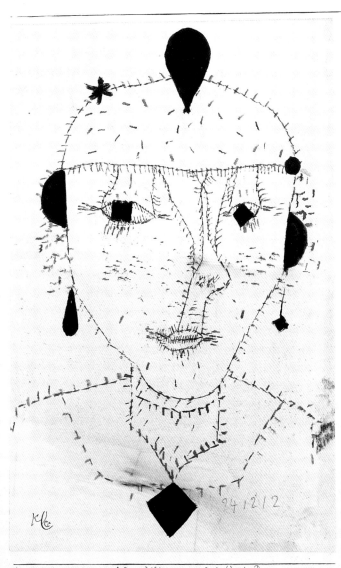

1924 270 Bildnisskizze einer kostümierten Dame

33. Curtain (Vorhang), 1924

Watercolor on madder- and glue-primed linen, bordered with watercolor on the cardboard mount
Linen 18.1 x 9.2 cm; linen and border 20.4 x 10.1 cm; cardboard 28.2 x 17.2 cm
Solomon R. Guggenheim Museum, Hilla Rebay Collection 71.1936 R115

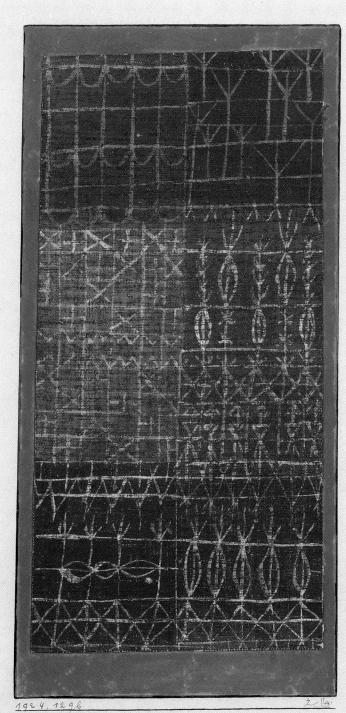

1924. 129 b. 2 1/4.

für Fräulein Grunow

34. *Portrait of Mrs. P. in the South* (*Bildnis der Frau P. im Süden*), 1924

Watercolor and oil transfer drawing on paper, bordered with gray gouache on the pulpboard mount

Paper 37.6 x 27.4 cm; pulpboard 42.5 x 31 cm

Peggy Guggenheim Collection, Venice 76.2553 PG89

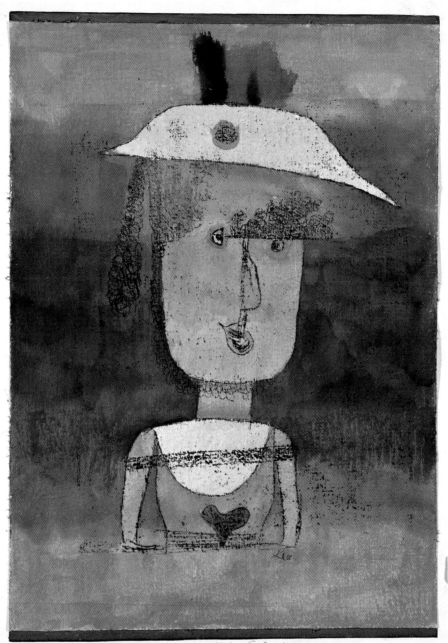

1924 243 Bildnis der Frau P. im Süden

35. *Signs in the Sky* (*Landschaft mit Himmelszeichen*), 1924

Oil on paper, bordered with watercolor on the cardboard mount

Paper 19.7 x 28.6 cm; cardboard 21.3 x 29.9 cm

Solomon R. Guggenheim Museum 48.1172x110

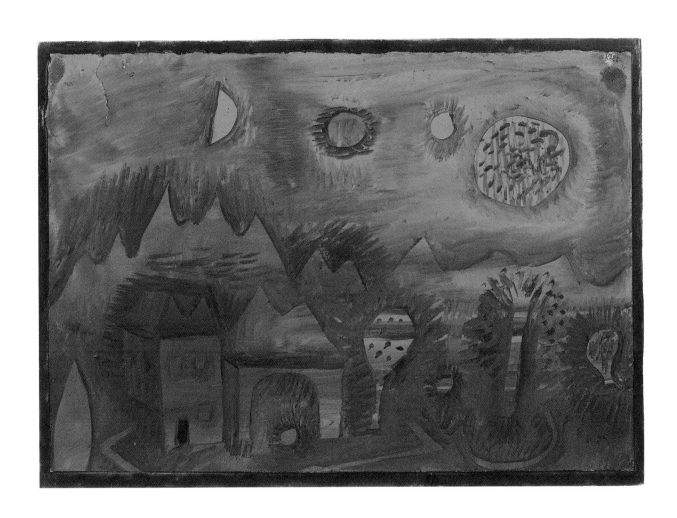

36. *Tree Culture (Baum Kultur)*, 1924
Watercolor and oil transfer drawing on paper, bordered with watercolor on the cardboard mount
Paper 47.4 x 34.9 cm; paper and border 48.7 x 34.9 cm; cardboard 60.5 x 47.2 cm
Solomon R. Guggenheim Museum 38.511

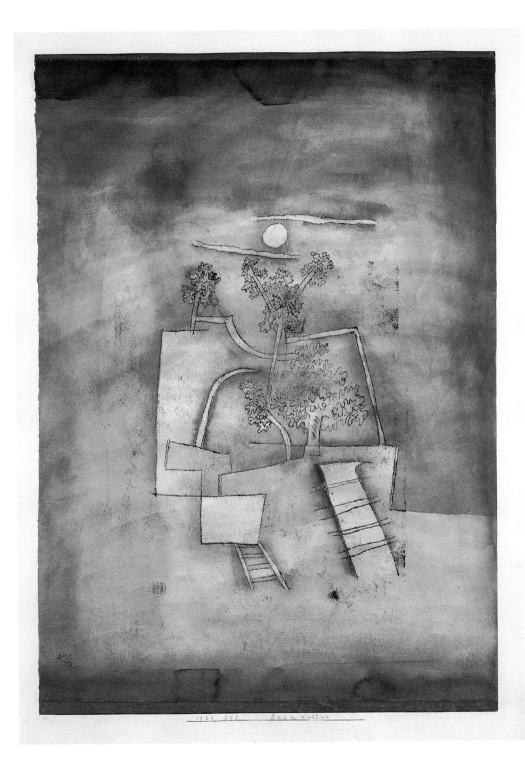

1924 145 Baum-Kultur

37. *Bearded Man (Head) (Bärtiger Mann {Kopf})*, 1925
Lithograph on paper
Image 22.3 x 15.3 cm; sheet 28.2 x 22.2 cm
Solomon R. Guggenheim Museum 48.1172x365.6

1925 R.4.

38. Horizon, Zenith, and Atmosphere (Horizont, Gipfelpunkt und Atmosphäre), 1925
Watercolor on paper, mounted on board
Paper 37.9 x 26.9 cm; board 38.4 x 27.6 cm
Solomon R. Guggenheim Museum 48.1172x533

39. *Inscription* (*Inschrift*), 1926

Watercolor and ink on paper, mounted on cardboard
Paper 23.5 x 14.6 cm; cardboard 31.1 x 22.2 cm
Solomon R. Guggenheim Museum, Gift, Solomon R. Guggenheim 41.343

I 1926. K.7. Inschrift

40. *Magic Garden* (*Zaubergarten*), March 1926

Oil on gypsum-plaster-filled wire mesh, mounted in artist's wood frame
Plaster 50.2 x 42.1 cm; plaster and frame 52.9 x 44.9 cm
Peggy Guggenheim Collection, Venice 76.2553 PG90

41. *Naked Lady (Nackte Frau)*, 1926

Ink on paper, mounted on cardboard
Paper 25.7 x 30 cm; cardboard 37.2 x 37.4 cm
Solomon R. Guggenheim Museum 48.1172x122

1926 X 7 nackte Frau

42. *Owl Comedy (Eulen Komödie)*, 1926

Watercolor and ink on paper, mounted on paper
Paper support 31.7 x 46.9 cm; paper mount 45.8 x 61 cm

Solomon R. Guggenheim Museum 39.512

43. *Fleeing Ghosts (Spooks)* (*Spukhaftes*), 1927

Ink on paper, mounted on bristol board

Paper 24.4 x 30.8 cm; bristol board 34.3 x. 34.3 cm

Solomon R. Guggenheim Museum, Gift, Katharine Kuh 75.2198

1927 A 9 Spukhaftes

44. *Pagodas on Water* (*Pagoden am Wasser*), 1927

Ink on paper, mounted on paper
Paper support 48.2 x 31.1 cm; paper mount 59.7 x 41.3 cm

1927 M.9. Pagoden am Wasser

45. *Portrait Sketch of Mrs. Hck. 3 (Bildnis Skizze Frau Hck. 3)*, 1927
Oil transfer drawing on chalk-primed newspaper, mounted on paper
Paper support 37.2 x 27.6 cm; paper mount 43.4 x 33.6 cm
Solomon R. Guggenheim Museum 48.1172x134

Klee

1927 H 4 Bildnis-Skizze Frau Het. 3

46. *South Coast of Porquerolles* (*Südküste Porquerolles*), 1927

Crayon on paper, mounted on paper
Paper support 29.1 x 33.1 cm; paper mount 37 x 39.2 cm

1927 T.10. Südküste Porquerolles

17 *Verging on Despair, Portrait (Bald verzweifeld, Bildnis)*, 1927
Ink on paper, mounted on paper
Paper support 46.4 x 30.5 cm; paper mount 64.8 x 47 cm

1929 T.10 bald verzweifelter, Bildnis

48. *Animal Look* (*Tierblick*), 1928

Ink on paper, mounted on paper

Paper support 28.8 x 21.6 cm; paper mount 38.2 x 32.3 cm

Solomon R. Guggenheim Museum 48.1172x123

1928 H.1. tier blick

49. *Bandaged Head* (*Verbundener Kopf*), January 1, 1928

Ink on paper, mounted on paper

Paper support 25.4 x 22.3 cm; paper mount 34.2 x 28.4 cm

Solomon R. Guggenheim Museum 48.1172x483

1.1.28

Klee

1928 R 3 verbundener Kopf

50. *In the Current Six Thresholds* (*In der Strömung sechs Schwellen*), 1929

Oil and tempera on canvas

43.5 x 43.5 cm

Solomon R. Guggenheim Museum 67.1842

51 *Trees behind Rocks (Bäume hinter Felsen)*, 1919

Pencil on paper, mounted on paper

Paper support 20.9 x 32.8 cm; paper mount 28.5 x 39.3 cm

Solomon R. Guggenheim Museum 48.1172x133

1929 K.6. Bäume hinter Felsen

52. *Open Book (Offenes Buch)*, 1930

Water-based paint and varnish over white lacquer on canvas

45.7 x 42.5 cm

Solomon R. Guggenheim Museum 48.1172x526

53. *A Pious One* (*Ein Frommer*), 1931

Pencil on paper, mounted on paper
Paper support 47.8 x 42.8 cm; paper mount 61.6 x 49.9 cm

1931.N.5 ein Fremmer

54. *In Angel's Keeping (In Engelshut)*, 1931
Colored inks on paper, mounted on paper
Paper support 42.1 x 49.1 cm; paper mount 50 x 64.9 cm
Solomon R. Guggenheim Museum 48.1172x486

1931. 4. 15. in Engelshut

55. *In Readiness (Bereitschaft)*, 1931

Pencil on paper, mounted on paper
Paper support 31.1 x 53.3 cm; paper mount 41.6 x 64.7 cm
Solomon R. Guggenheim Museum 48.1172x152

1931 IX.12 Bereitschaft

56. *Lying As Snow (Als Schnee liegend)*, 1931

Ink on paper, mounted on paper

Paper support 31.3 x 47.7 cm; paper mount 47.6 x 62.6 cm

1931. 10. als Schnee liegend

57. *The Clown Emigrates (Der Clown wandert aus)*, 1931
Colored inks on paper, mounted on paper
Paper support 43.4 x 36.5 cm; paper mount 65 x 50 cm
Solomon R. Guggenheim Museum 48.1172x492

1931 K 9 der Clown wandert aus

58. *Barbarian Sacrifice* (*Barbaren-Opfer*), 1932

Watercolor on paper, mounted on paper
Paper support 62.9 x 48 cm; paper mount 64.8 x 49.8 cm

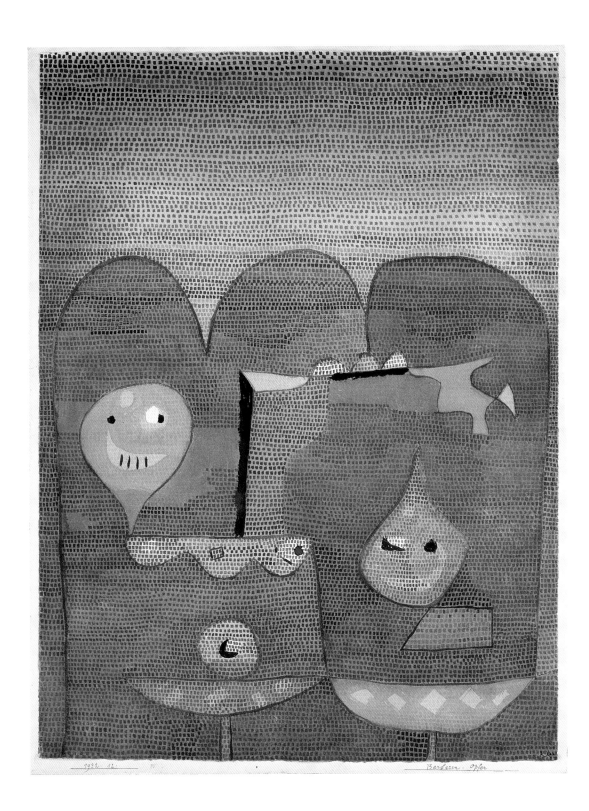

1932. 11. IV Barbaren - Opfer

39. *Dawn (Dämmerung)*, 1932

Ink or watercolor wash on colored paper, mounted on paper

Paper support 36.8 x 23.2 cm; paper mount 45.9 x 29.2 cm

Solomon R. Guggenheim Museum 48.1172x136

1932 Z 15. Dämmerung

60 *Hat, Lady, and Little Table (Hut, Dame und Tischchen)*, 1932
Gouache and watercolor on plaster-primed burlap, mounted on board
Burlap 63.5 x 35.6 cm; board 66.7 x 36.2 cm
Solomon R. Guggenheim Museum 77.2292

1932 Hut, Lampe und Tischchen

61. *Loose Coil* (*Loser Knäul*), 1932

Watercolor on paper, mounted on paper
Paper support 16.8 x 47.6 cm; paper mount 41.9 x 64.8 cm

1932 V 12 loser Knäul

62. *Public Duel (Öffentliches Duell)*, 1932

Watercolor and india ink on tissue paper, mounted on paper
Paper support 48.9 x 37.6 cm; paper mount 65 x 49.9 cm

1932 y= 11 öffentliches Duell

63. *Three Young Couples (Drei junge Paare)*, 1932
Watercolor and ink on chalk-primed paper, mounted on paper
Paper support 22.6 x 37.1 cm; paper mount 31.1 x 43.4 cm
Solomon R. Guggenheim Museum 48.1172x74

1932 qu 6 drei junge Paare

64. *Two Ways (Zwei Gänge)*, 1932

Black watercolor on paper, mounted on paper
Paper support 31.3 x 48.4 cm; paper mount 44.3 x 61 cm

Solomon R. Guggenheim Museum 48.1172x139

1932 V.16 Zwei Gänge

65. *Classical Ruins (Klassische Trümmer)*, 1933

Watercolor on paper, mounted on cardboard
Paper 35.6 x 51 cm; cardboard 41 x 53.2 cm
Solomon R. Guggenheim Museum 48.1172x144

1933 K 19 Clasische trümmer

66. *New Harmony (Nove Harmonie)*, 1936

Oil on canvas

93.6 x 66.3 cm

Solomon R. Guggenheim Museum 71.1960

67. *Arches of the Bridge Break Ranks (Brückenbogen treten aus der Reihe)*, 1937

Charcoal on cloth, mounted on paper

Cloth 42.6 x 42 cm; paper 50 x 46.8 cm

68 *Fruitfulness (Fruchtbarkeit)*, 1937

Watercolor and charcoal on chalk- and glue-primed newspaper, mounted on paper
Newspaper 48.7 x 33.3 cm; paper 63.5 x 48.2 cm
Solomon R. Guggenheim Museum 38.517

1937 p 15 Fruchtbarkeit

69. *Peach Harvest (Pfirsich=Ernte)*, 1937

Watercolor and charcoal on chalk- and glue-primed paper, mounted with linen strips on paper
Paper support and linen strips 55.2 x 43.5 cm; paper mount 64.1 x 49.9 cm
Solomon R. Guggenheim Museum 38.518

1937. 7 17. Pfirsich-Ernte

79. *Pomona Growing Up (Pomona heranwachsend)*, 1937

Oil on paper, mounted with cloth strips on paper
Paper support and cloth strips 55.5 x 37.5 cm; paper mount 64.4 x 49.8 cm
Solomon R. Guggenheim Museum 38.516

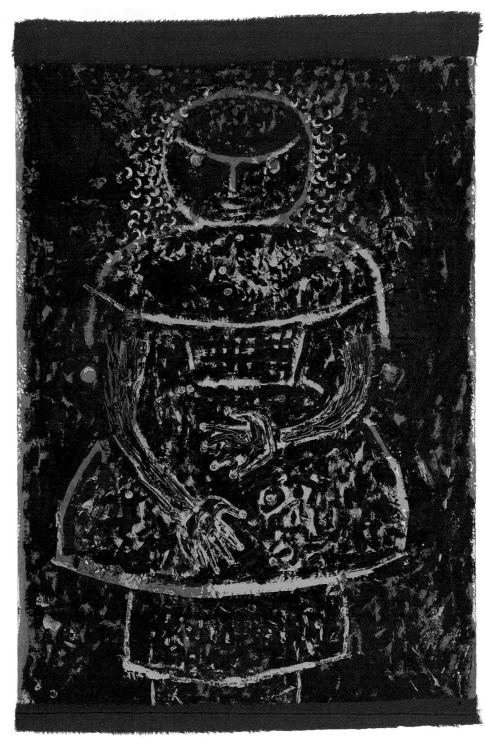

1957. No 15. Personnage humuni soit

71. *Park near B. (Park bei B.),* 1938

Watercolor on chalk-primed paper, mounted on paper
Paper support 22.9 x 15.9 cm; paper mount 37.4 x 30.2 cm
Solomon R. Guggenheim Museum, Hilla Rebay Collection 71.1936 R112

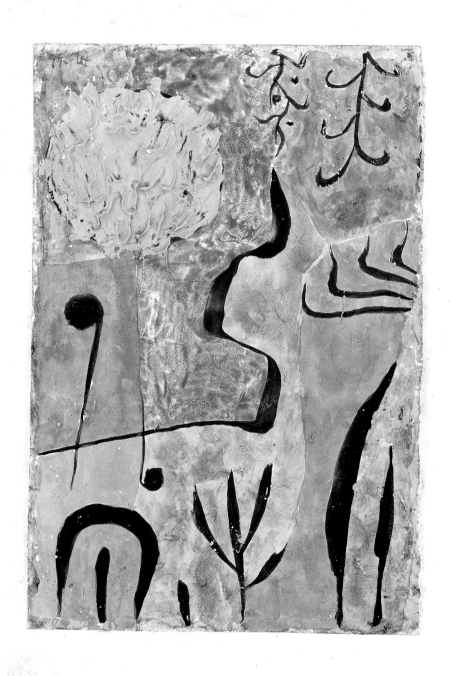

1938. E.1 Park bei B.

72. Rolling Landscape (Wogende Landschaft), 1938

Watercolor on chalk- and glue-primed sailcloth, mounted on board with painted built-up chalk and glue

Sailcloth 40.2 x 54.2 cm; board 47.1 x 61.9 cm

Solomon R. Guggenheim Museum 48.1172x529

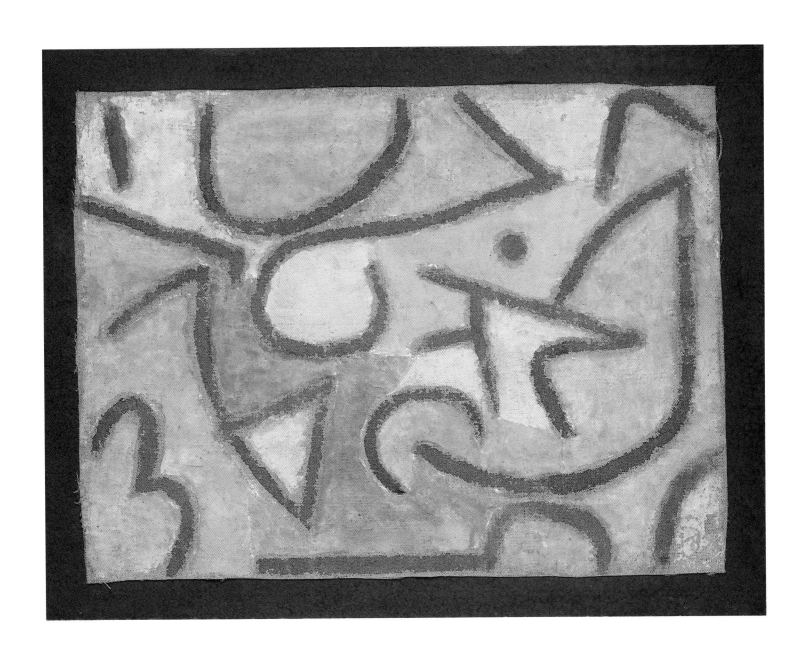

73. *Severing of the Snake (Zerteilung der Schlange)*, 1938
Watercolor on burlap, mounted on burlap primed with built-up chalk and glue, mounted on board
Burlap approximately 52.1 x 39.4 cm; board 72 x 58.4 cm
Solomon R. Guggenheim Museum 48.1172x57

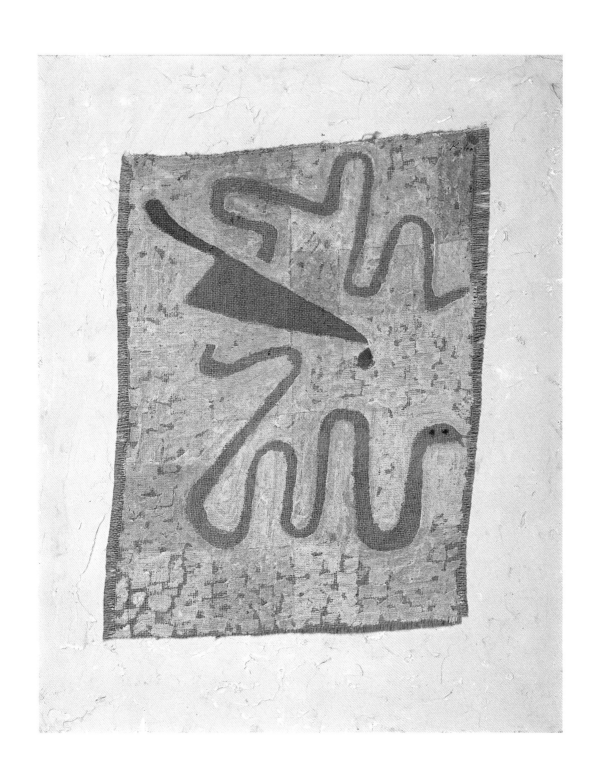

74. A Barren One (Eine Unfruchtbare), 1939
Watercolor and ink on paper
26.7 x 42.4 cm
Solomon R. Guggenheim Museum 48.1172x72

75 *Rocks at Night (Felsen in der Nacht)*, 1939

Watercolor and ink on chalk- (?) and glue-primed letter paper, mounted on paper
Paper support 20.9 x 29.5 cm; paper mount 27.6 x 36.2 cm
Solomon R. Guggenheim Museum 48.1172x538

1939 K3 Felsen in der Nacht

76 *Will It Be a Girl? (Wird es ein Mädchen?)*, 1939

Oil and water-based paint on two layers of burlap with plaster priming, mounted on plaster-primed board

Burlap 52.5 x 53.2 cm; board 71.4 x 71.1 cm

Solomon R. Guggenheim Museum 48.1172x58

77. *Boy with Toys (Knabe mit Spielsachen)*, 1940
Colored paste on paper, mounted on paper
Paper support 29.2 x 20.6 cm; paper mount 40.4 x 31.2 cm
Solomon R. Guggenheim Museum 48.1172x70

1940 M9 Knabe mit Spielsachen

Credits

Exhibition Curator
Lisa Dennison

Curatorial Assistant
Juliet Nations-Powell

Research
Katharina Katz

Managing Editor
Anthony Calnek

Assistant Editor
Laura Morris

Editorial Assistant
Jennifer Knox

Photography
David Heald
Lee Ewing

Design
Michelle Martino

Color Separations
Color Control, Inc., Redmond, Washington

Printing
Ediciones El Viso, Madrid, Spain